D1301201

CITY OF REFUGE

A 9/11 MEMORIAL

RICHMOND HILL
PUBLIC LIBRARY

JAN 6 2010

RICHMOND GREEN
905-780-0711

CITY OF REFUGE
A 9/11 MEMORIAL

KRZYSZTOF
WODICZKO

EDITED BY

MARK JARZOMBEK
MECHTILD WIDRICH

black dog
publishing
london uk

CONTENT

FORE
WORD

MARK
JARZOMBEK

MECHTILD
WIDRICH

Krzysztof Wodiczko is internationally renowned for his large-scale slide and video projections on architectural facades and public monuments. These works are both a subversive critique of the authority of classical monuments and an activation of their dormant potential. They investigate the relationship between art and democracy—the latter always considered an unfinished project—in particular bringing up the themes of justice, violence and speech.

City of Refuge: A 9/11 Memorial extends the themes of Krzysztof Wodiczko's interests in the monument and critical enactment of democracy into the realm of architecture and urban design. It is a proposal for a 9/11 memorial born of the author's frustration with the official American reaction to the catastrophe, from the invasions of Afghanistan and Iraq to the plans for Ground Zero. Wodiczko has no intention of replacing the official design by Michael Arad and Peter Walker, but seeks rather to complement it with the political, humanitarian, and moral-philosophical functions embodied in his City of Refuge: a title which he would like to apply to all of New York City. Though the project has no purely aesthetic ambitions—this is no attempt to 'make poetry after 9/11'—Wodiczko does wish to replace the regime he holds responsible for the ongoing political catastrophe. It is worth keeping in mind that the proposal, suggestively dated September 11 2001–2007, is a protest against policies of former President George W Bush, who was not at all 'former' at the time the project came into being. These policies will have an impact on global politics for a long time.

Wodiczko's proposal is not a conventional 'artwork' accompanied by a theoretical text, but rather a text—a manifesto of sorts—accompanied by a set of drawings that Wodiczko made to help visualize his argument. The argument Wodiczko makes relies on the ethical philosophy of Emmanuel Levinas, is in fact the core element of his proposal. Since a central theme is the agonistic dialogue that optimizes opportunities for people to express their disagreements, we thought the text should be accompanied by critical essays as a starting point for debate and discussion. According to Wodiczko's own political thinking, the proposal ought to be analyzed, framed, and even challenged at the outset. We also did not wish the text to be seen as a stand-alone pronouncement isolated between the covers of a book. Instead we have tried to rise to the challenge posed by literary critic IA Richards' dictum that "a book is a machine to think with".

Some of the responses discuss the utopian reach of the proposal, and the actual practical possibilities of Wodiczko's endeavor. Some put the memorial in broader art historical and political frameworks, explore the work's motives, moral and psychological, or survey its place in the political landscape of the US. The way in which trauma is a profound underlying issue in this proposal and the senses in which trauma could be approached by art are concerns which recur in these essays. Other affinities and differences between the author and respondents, and between the respondents themselves, are left to the reader to explore. We will mention just one: neither the memorial nor the responses try to 'cure' the trauma of 9/11, to solve the political crisis, or even to offer advice for how to go about doing these things. Rather, this book may be seen as a small machine, giving the reader some of the pieces with which to construct a framework for debate and critical memory.

A MEMORIAL FOR
SEPTEMBER 11

A PROPOSAL FOR
NEW YORK CITY
AS AN INTENTIONAL
CITY OF REFUGE

KRZYSZTOF
WODICZKO

AN INTRODUCTION

This proposed memorial to September 11 is a project parallel and supplemental to the World Trade Center Memorial presently under construction. Its aim is to create a place for a more active, critical, and discursive memory of the September 11 attack, examined in its historical and political context, in the light of the military action taken in its wake, and its domestic and international fallout. The memorial will be a place for operative memory, memory in action. It will be an interrogative and "agonistic", not antagonistic, institute of memory, a public forum and base from which to initiate new transformative projects.[1]

It is only through such work that a memorial can contribute to the prevention of global injustice, arrogance, ignorance, and disrespect, which, if not stopped, will continue to ignite anger and provide fertile ground for new attacks.

It will be a working memorial, an active, engaged and engaging, socially inclusive institution, a network as well as an organization. Its public programs and events in remembering and recollection will aim to inspire, provoke and assist in the process of raising consciousness and knowledge of our unintentional role and indirect implication in the misery of the world, even when our action and its effects unfold at a distance, in terrains and territories little known to us.

The founding reference for this memorial is the ancient Jewish notion of "half-guilt and half-innocence" and the biblical blueprint for "Cities of Refuge" related to it. In one of his Talmudic lectures, ethical philosopher Emmanuel Levinas reintroduced and actualized this notion as a powerful ethico-political metaphor for our Western globalizing attitude and the concomitant lack of consciousness of the crimes and injustices unintentionally (or half-intentionally) committed towards those less fortunate and less prosperous than ourselves.

In the face of the continuing and seemingly uncontrollable and unavoidable bloody conflicts and man-made catastrophes, further critical re-actualization of the ethico-political paradigm and metaphor of Cities of Refuge remains an imperative for our social survival and for the advancement of our civilization.

In this global context any political and ethical consciousness of our half-guilt and half-innocence gained is a valuable start, and a necessary, albeit insufficient, first step. Our goal is to move even beyond that consciousness, beyond even an intelligent emotional reflection, beyond a psychoanalytical process of "working-through" the trauma of September 11.[2] One must take a further step. One must begin doing something about our present world. One must transform it.

A new, inspiring and evocative institution is needed for the advancement beyond consciousness, toward an informed and responsible practice in the world, free of recklessness, ignorance, arrogance, and

self-centered deeds, toward a world liberated from irresponsibly unintentional, harmful and destructive actions and inactions.

In the proposed memorial the focus on memory will be complemented by a concentration on learning, research, and proactive programs of engagement, and will encourage new and informed practical initiatives and actions, creating the hope of paving a way to a safer and less miserable, unjust and violent world. As a place for memory in action, the September 11 memorial will attempt to radically contribute to this direction. The following text is an elaboration and description of the proposed memorial, formulated as a political and ethical argument.

THE BIBLICAL CITIES OF REFUGE: EMMANUEL LEVINAS' INTERPRETATION

1. Speak to the children of Israel, saying: "Assign you the cities of refuge, whereof I spoke unto you by the hand of Moses; that the manslayer that killeth any person through error and unawares may flee thither; and they shall be unto you for a refuge from the avenger of blood.

And he shall flee unto one of those cities, and shall stand at the entrance of the gate of the city, and declare his cause in the ears of the elders of that city; and they shall take him into the city unto them, and give him a place, that he may dwell among them.

And if the avenger of blood pursue after him, then they shall not deliver up the manslayer into his hand; because he smote his neighbour unawares, and hated him not beforetime.

And he shall dwell in that city, until he stand before the congregation for judgment, until the death of the high priest that shall be in those days; then may the manslayer return, and come unto his own city, and unto his own house, unto the city from whence he fled."

These were the appointed cities for all the children of Israel, and for the stranger that sojourneth among them, that whosoever killeth any person through error might flee thither, and not die by the hand of the avenger of blood, until he stood before the congregation.

The Book of Joshua 20:2–6, 9

And this is the case of the manslayer, that shall flee thither and live: who killeth his neighbour unawares, and hated him not in time past; as when a man goeth into the forest with his neighbour to hew wood, and his hand fetcheth a stroke with the axe to cut down the tree, and the head slippeth from the helve, and lighteth upon his neighbour that he die; he shall flee unto one of these cities and live; lest the avenger of blood pursue the manslayer, while his heart is hot, and overtake him, because the way is long, and smite him mortally; whereas he was not deserving of death. Insomuch as he hated him not in time past.

Wherefore I command thee, saying: "Thou shalt separate three cities for thee."

Deuteronomy 19:4–7
Hebrew-English Bible (Mechon-Mamre)

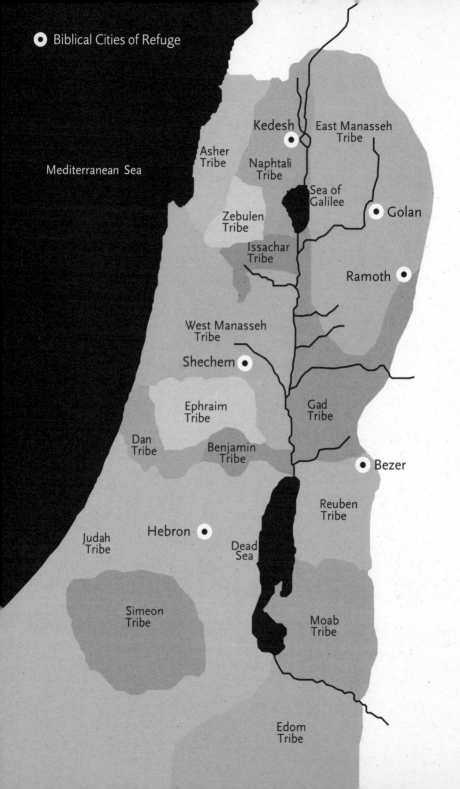

2. A murder committed as an unwitting act or homicide; when, for example—a biblical example—an axe-head comes away from its handle during the work of the woodcutter and deals a mortal blow to a passerby, this murder cannot be pursued before the court of judgment.

Do not these murders, committed without the murderers' volition, occur [today] in other ways than by the axe-head leaving the handle and coming to strike the passerby?

In Western society—free and civilized, but without social equality and rigorous social justice—is it absurd to wonder whether the advantages available to the rich in relation to the poor—and everyone is rich in relation to someone in the West—whether these advantages, one thing leading to another, are not the cause, somewhere, of someone's agony? Are there not, somewhere in the world, wars and carnage, which result from these advantages?

The cities in which we live and the protection that, legitimately, because of our subjective innocence, we find in our liberal society (even if we find it a little less than before) against so many threats of vengeance fearing neither God nor man, against so many heated forces—is not such protection, in fact, the protection of a half-innocence or a half-guilt, which is innocence but nevertheless also guilt—does not all this make our cities cities of refuge or cities of exiles?
Emmanuel Levinas, "Cities of Refuge"[3]

In his Talmudic lecture "Cities of Refuge", Levinas refers to the biblical example of an unintentional act of homicide committed by a woodcutter: while chopping wood, his axe's blade came away from the handle and killed a passerby. A killing has occurred but without intention to harm.

One may assume that the deadly accident may have happened out of carelessness, inattention or recklessness. It may have resulted from a disregard for the (potentially grave) impact of one's own action on the lives of others, or from a non-action—a passivity in the face of one's own lack of professional qualifications. But it was not a crime committed deliberately and consciously; the woodcutter may have been guilty of social blindness and ethical numbness, but did not commit proper murder. Nonetheless, a killing had occurred and, bound by the ancient law of "an eye for eye", the victim's next-of-kin or another kinsman had a right, even a duty, to take vengeance and put the slayer to death.

By the Law of Moses, any person who committed homicide (whether later proven to be intentional or not), had the right to immediately flee to one of the six Cities of Refuge. In these cities, especially designed against infiltration by the "avengers of blood", the manslayer's life was protected until he or she could be safely brought back to the site of the tragic event, or to the city's temple, for proper trial. When the defendant's lack of intention was proven and he or she was pronounced as half-innocent, half-guilty—guilty of causing a foreseeable accident in which there was some degree of negligence involved—the unwilling manslayer was sent back to the City of Refuge to live there in safety.

Yet, as the Bible implies, and Talmudic discourse further interprets and elaborates, the City of Refuge was not solely a sanctuary, a place of safety or of humane life. It was also, perhaps even more than anything else, a place for study. As Emmanuel Levinas reminds us, the safe sanctuary of the Cities of Refuge came with the responsibility to continue in-depth learning of the Torah.

One may assume, that, in the Cities of Refuge, the obligatory study of the Torah must have been conducted with specific reference to the deadly events in which the exile was so profoundly implicated. It would have recalled the causes and consequences of the slayer's inadvertent actions and their impact on others, while envisaging alternative modes of living and thinking and securing conditions under which the deadly mistakes would not happen again.

Its role would be, in Walter Benjamin's words, to "recall the past" critically, to save it from unthoughtful commemoration, and to reenvision the future so that coming generations will be freed from the danger of unintentional crimes and from repeating the mortal mistakes of the past.

The City of Refuge was a place of critical memory—not a site of melancholic, passive and narcissistic commemoration of the tragic events and one's own deadly mistakes. It was a non-passive memorial project, a project for re-thinking, not a refuge from but for the memory-work, for an analytical and critical reconstruction of past events, deeds, and modes of thinking (or non-thinking) that may have led to the 'accident'.

Talmudic discourse seems to imply that the Cities of Refuge may have been designed to accommodate a complex learning program, a sort of ethical, and in necessary ways political and educational urban network suitable for disciples, their Masters, and possibly even their colleges.

Assuming that the aim of the Cities of Refuge was to inspire and secure the process of mourning (working-through), such a process must have demanded the protection of sufficient time and space for thinking and re-thinking, for cross-generational dialogue, and, in accordance with Jewish tradition, for thorough study, analytical and critical discussion, good argument, and in-depth re-actualization of the learned material.

NEW YORK CITY IN THE AFTERMATH OF SEPTEMBER 11: A SPONTANEOUS MEMORIAL

In the aftermath of September 11, the entire City of New York became one large spontaneous memorial site, a memorial that took the form of three simultaneous commemorative projects: a massive public commemoration of those who lost their lives; a massive public forum for passionate ethico-political commentary and discussion; and, on a smaller scale, but equally important, a conciliatory anti-war trip to Afghanistan by

some New Yorkers who lost loved ones in the September 11 attack.

The thousands of graphic and textual obituaries and tributes to victims of bombing were supplemented by thousands of warnings, reflective and critical statements and commentaries. The statements advocated analysis, advised thinking historically, warned against vengeful actions, either at home or abroad, denounced anti-Arab and anti-Muslim reactions, and recalled American historical mistakes and tragedies (such as Vietnam).

Graffiti and posters such as "Jews and Muslims Unite!", "No War!", "No Eye for an Eye!", "There is a Terrorist in Each of Us!", and others, encircled the arch in Washington Square Park and covered and transformed the statue of Washington at Union Square, in many ways re-actualizing and reinterpreting these and many other politically and historically charged urban sites and symbolic structures. For one month New York City had transformed itself into a commemorative agora, a place of agonistic memory, a discursive and proactive memorial, culminating in that remarkable instance of anti-revenge—the peace-making trip to Afghanistan.

In the Bible, Cities of Refuge were conceived by Moses to protect the unintentional manslayer from the "avenger of blood". They would protect those guilty of causing foreseeable accidents (in which there was some degree of negligence involved)—the half-guilty and half-innocent—from the deadly revenge by the victim's family. In his Talmudic reading, Levinas has interpreted six such biblical Cities as a metaphor for Western ones today.

If only for that month, in the aftermath of September 11, unintentionally, but intensely and on an overwhelming scale, New York City brought back to life (and lived through) ethical, discursive, and critical ways of mourning that in some sense resembled the tasks and methods laid down for the biblical Cities of Refuge.

After five years of melancholic semi-resignation (interrupted only on special occasions by anti-war protests) and due to the growing dissatisfaction with the government's conduct of the "war against terror", foreign and domestic, New Yorkers are invigorated again in their re-thinking of all these costly military actions, bloody in their outcome and implications; they are regretting the lack of a new political, economic and ethical analysis and of a new, more responsible and responsive global policy.

AN ARCHITECTURE OF "ACTING OUT" AND "PREMATURE CLOSURE": THE NEW WORLD TRADE CENTER AND THE NEW OFFICIAL MEMORIAL[4]

Although the official competition for the new World Trade Center and its Memorial has now been resolved, there was never a thorough, open and inclusive public

discussion of how we should understand the meaning and function of commemoration of the September 11 attacks, and of how to envisage the social and symbolic possibilities of commemoration.

The public discussions provoked by the architectural competition for a new World Trade Center and Memorial could serve only as a poor substitute for the wider and much needed philosophical, political, ethical and psychoanalytical discourse. The discussions touched upon what may be important, but not on all that is important. They were structured around the choice of a symbolic form of commemoration and of an appropriate architectural symbolism, as well as around issues of the Center's safety, touristic value, commercial program, and the like.

The massive high-altitude bombing of Afghanistan (and later Iraq), the plans to build a new World Trade Center even taller than before, the entrenchment of the Memorial in the destroyed towers' footprints, and the practice of calling the victims who lost their lives in the attack "heroes", have become a quadruple manifestation of architectural and monumental acting out, melancholia and premature closure.

The President of the US appointed himself chief architect and public artist in this project. Wearing a hardhat, he abruptly arrived at Ground Zero (a term originally coined by the American military to designate the point on the ground directly below the epicenter of Hiroshima's bombing) and made it implicitly clear to New Yorkers still absorbed in their public mourning and debates that the World Trade Center catastrophe, with all its loss and trauma, could no longer be New York City's own drama. The tragedy, he implied, must become instead a matter to be dealt with by the Federal government, a government about to respond to the attack in line with the new global mission of the US, the nation's new will and destiny—the "war on terror".

The essence of the President's speech could be summarized as follows: "New Yorkers, stop thinking! Be true Americans! Start acting! Join the will of the Nation!"

The capital, eager to act, or rather to act out, has lost patience with the metropolis' memory-work, with its working-through process—its mourning.

NEW YORK CITY AS AN UNINTENTIONAL CITY OF REFUGE: A RETURN TO EMMANUEL LEVINAS' QUESTIONS

Following Walter Benjamin's method in the philosophy of history, the ancient Cities of Refuge represented for Emmanuel Levinas a very special notion of the past: the past that happened "as if it were anticipating the present".[5]

In his lecture Levinas posed many questions that not only anticipated September 11, but also measures taken by the Homeland Security, the recent immigrant riots in France, London's terrorist bombings, the recently planned attacks on US airlines and airports, the recent Israeli-Hezbollah war, the now widespread anti-Western, anti-American, anti-Israeli attitudes (with their vengeful 'blood-heat'), as well as our growing fear of Arab and Muslim 'terrorism'.

Let us return to Levinas' questions, albeit in a somewhat expanded and re-actualized form:

• Fortunate and privileged as we are, are we not today living as if in biblical Cities of Refuge?

• As residents of fortunate cities of the North, are we not half-innocent and half-guilty (of the misfortune of the cities of the South)?

• Have we not neglected to see the link, even causality, between our prosperity and their misery?

• Have we not turned a blind eye, not only to the extreme poverty of the cities of the South, but also to the vast impoverished sections of our own cities?

• Have we not, through ignorance and passivity, unintentionally contributed to the perpetuation of a gross economic and political asymmetry that incites manslaughter and provides fertile social and political ground for the barbarous terrorism of today and tomorrow?

• Are we not potential unintentional manslayers?

• Do we not seek refuge in our prosperous and well-protected urban districts against potential "avengers of blood" that may attack us within and without our cities, and who, with "heated blood" may somehow break through any Homeland Security measures and attack us again?

• Is it not the purpose of our gated communities, as well as our monumental real-estate citadels established both inside and outside, or on the outskirts of our cities, to protect us from the 'violence' of the city proper and from seeing and experiencing the painful problems of the world around us?

• Do we not mindlessly enjoy our protected refuge, while not wanting to know the details of unjust, even unconstitutional, detentions and deportations and the inhuman and illegal conditions in detention centers set up by our Homeland Security, in the name of keeping "avengers of blood", real or imaginary, away from us?

• Do we not, as intellectuals and artists, seek protected places to study toward our graduate degrees in ethico-political studies, in analogy to the exiles of biblical Cities of Refuge designed for learning and protection?

• Are we not hoping to become philosophically 'advanced', mentally and intellectually 'healthy', free of 'melancholy', "ideological fantasies", xenophobic projections, cured of not opening

up to the "Other", while busy with new and proactive agendas and projects toward the bloodless, passionate, and truly democratic world to come? Is there, in such a critical and analytical attitude, no substantial hint of our healthy proactive attempt to confront our part-guilt and part-innocence?[6]

• And applying an expression of Gilles Deleuze to the Cities of Refuge agenda: Is this not a truly "critical and clinical" project?[7]

• According to the Bible, an "avenger of blood" was to be absolved of his or her obligation to put to death the unintentional killer only after the death of the high priest of the city where the tragic accident happened. This was to be the end of enforced refuge for the exile, and he or she was now free to safely exit the gates of the City of Refuge and return home. Are not at least some among the "avengers of blood" waiting for the death, or the end of tenure of their 'high priests'—politicians, politico-religious or spiritual leaders—so as to be free from their bloody obligations of revenge?

• Furthermore, in the biblical Cities of Refuge, it was never allowed to carry on a trade in arms, and the use of animal traps, or tools and architectural features an "avenger of blood" could turn into a weapon was totally prohibited. The cities were designed as large open spaces with no forts or defensive walls, so that an avenger would be publicly visible and have difficulty penetrating the city or hiding there.

Do we not, with our new security measures, fear infiltration by "avengers of blood"—thus redesigning our municipal regulations and modus operandi in similar directions? (In this respect, New York City's post-September 11 security procedures may be already over-designed.) The slogan "If you see something, say something" acoustically and visually dominates the city's subways, train stations, buses, bus stops, and other public places.[8]

Let us hope that there may be at least one relevant analogy here.

TOWARD NEW YORK CITY AS AN INTENTIONAL CITY OF REFUGE

Lacking an awareness of residing in our own city as if it were a City of Refuge (for we never intentionally 'fled' to it as exiles), it may be fair to say that our life in it has been ethically and, as a consequence, politically naïve. Our city never demanded of us any special obligations or responsibilities in exchange for sanctuary from an "avenger of blood". We came with no sense of real danger, no necessity to explain upon our migration a mortal act to the elders before the city gates (though 60 percent of us arrive here in New York from other countries, with additional arrivals from other American cities). There is no need to stand trial back in the place of our unintentional crime, wherever it may have occurred, here or somewhere else, in some dangerous land far away.

More importantly, for us (and for our teachers), our safe exile placed no demand to study the wider meaning of our unintentional deeds, to seek new ways toward ethical, psychological and political recovery and change, for ourselves, our communities and the world.

It is only now, when reading Levinas' essay, that we are assigned the task of considering ourselves ethical exiles—critical and analytical students of our unintentional deeds, and thus potential agents of change— and the task of living in our city as if it were carrying on the ethical and political mission of the ancient Cities of Refuge. In this historical task Levinas has done part of the work for us already: he has judged us (in absentia), prequalified us as potential residents (pronounced us half-guilty and half-innocent), and reassigned our city a new status and mission as a City of Refuge.

New York City was clearly unprepared to function as an enclave of protection and safety. On September 11 (even previously, for the World Trade Center had been attacked before), the city was unable to defend itself from infiltration by "avengers of blood".

For us, unaware and unconscious of the destiny assigned to it by Levinas, New York City has been a city of unconscious exile, a truly unintentional City of Refuge. Despite its ethical naïveté and the unpreparedness of its military defense, it has proven its ethical strength and integrity in the aftermath of the attack, as it spontaneously managed to redesign itself as a place of study and critical reflection.

New Yorkers were thus ethically prepared to handle the emotional traumatic fallout from the World Trade Center bombings, while those responsible for their safety were militarily and politically unprepared. The Federal authorities failed to prevent the attack, and, as we see clearly today, could not and cannot handle its military and political fallout.

Due to draconian new Homeland Security measures and the effects of the Patriot Act, military and paramilitary attempts to protect us against "avengers of blood" are dramatically increasing, while our capacity to freely study, and to enjoy open and critical discussion of our deeds, intentional and unintentional, global and local (and our sense of obligation to do so) is dramatically decreasing.[9]

Were we to transform New York City into an intentional refuge, we would need to invent better ways to ensure its safety and self-defense, while challenging the fantasies and ideologies behind the present-day Homeland Security measures, the effects and affects of the Patriot Act and the real ethical and psychic function of real-estate citadels (such as Battery Park City, and the newly reinforced Stuyvesant Town and Peter Cooper Village).

Were we to accept the ethical and political mission assigned by our new consciousness, a consciousness that

might make us worthy of ethical and legal protection, we would need to turn our city into an intentional City of Refuge; we would need to re-think and transform it, develop new ways of living, working and enjoying life in it and re-discuss its organizational structures, perhaps even its bylaws, while supplementing it with specially designed institutions·and symbolic structures.

THE WAYS OF OUR HALF-GUILT AND HALF-INNOCENCE

The election and reelection of George W Bush, whose post-September 11 leadership has caused harm and deadly disruption worldwide and at home, is now seen by a majority of the population, including those who reelected him, as a tragic mistake. In the name of national security, the US government has invented and implemented a doctrine of the right of preemptive attack on any foreign lands, on the basis of mere suspicion of terrorist designs on the US. A similar preemptive doctrine has been deployed at home, against immigrants from 'Muslim' and 'terrorist' countries. Its implementation has led to detention or deportation of a large part of the targeted immigrant population, destroying families and depriving many children of a parent's support.

The effects of the Patriot Act, such as spying on US citizens and residents and taking various forms of action against 'potential'·enemies at home, bear the stamp of McCarthyism. This can be seen as a preemptive strike on the part of the government against domestic dissent, and on constitutional rights themselves.

This international and domestic policy is widely perceived as an assault against international law, the democratic process, the US Constitution, and civil liberties.

In the midst of the post-September 11 era many of us are feeling in some way responsible for the physical, mental or moral injury, lethal damage, and the daily suffering of others abroad and at home. Whether we wish to accept it or not, as US citizens, we are implicated in our government's irresponsible actions, actions that result in the suffering of Iraqi and Afghan civilians, in the illegal imprisonment and mistreatment of captives at Guantánamo Base, in the torture of victims captured abroad via 'extraordinary renditions', and in deportations and detentions of innocent immigrants whose families, left behind, become secondary victims of draconian Homeland Security measures.

In this situation the number of victims and survivors of the September 11 terrorist attack far exceeds the number of its primary casualties (those who lost their lives, were wounded or fell ill, and their family members and loved ones). Such a list may now include the innocent victims and survivors of the "war on terror", and the infinitely greater number of others who have suffered or died as a result of misguided and arrogant domestic and

international actions and wars irresponsibly staged by Americans and their allies.

Many American citizens now feel shame, as they feel partly responsible for their government's actions. Others simply blame the government for all its wrongdoing, and see themselves as its innocent and betrayed victims. Some actively join organized protests, stage public trials of the President, or publicly withhold their assent for the government to act and speak in their name as Americans. In disbelief and self-blame more and more Americans are critically recalling their astonishing post-September 11 passivity, inaction, lack of consciousness and conscience, political naïveté and poor judgment. Many feel at fault for allowing themselves to be led in the wrong direction by the wrong President, and for not challenging him, and his government's policy, firmly and swiftly enough.

This sense of half-guilt (and only half of the voting population elected this President) can only be exacerbated by our failure in 2004 to secure the election of a more complex political leader, one who thinks for the long term, rather than one who has further inflamed and manipulated public fears in order to introduce harsh counterterrorist laws and measures (themselves resembling terrorist methods), and issue himself a blank check for extraordinary powers and a continued 'state of exception'.

The population's state of part-guilt and part-innocence is also a result of the vast fallout from the war at home, the rapid repercussion of the secondary trauma propagated by the soldiers returning to their families.

The unintentionally or semi-intentionally violent or criminal nature of much of the military action, and the destructive and self-destructive social behavior of soldiers, both in war zones and back home, much of it because of post-traumatic stress, adds to the magnitude and intensity of this part-guilt and part-innocence.

Owing to the unprecedented use of National Guard and military reserves—often recalling to duty three or four times civilian reservists who, unlike younger regular soldiers, have large families—each traumatized soldier re-traumatizes five to nine members of his or her own family. Secondary war trauma is spreading across the country so rapidly that it cripples or destroys the lives of up to one-third of the entire US population. Soldiers' families are becoming war veterans as much as soldiers themselves. For too many back at home, peace is a continuation of war by other means.

As a result of new advanced boot camp desensitizing techniques, 80 percent of US soldiers are rendered capable of killing in Iraq and Afghanistan (only 20 percent did so in the Second World War). In this situation it must be very difficult for the returning soldiers to re-sensitize themselves back home, and there is no comprehensive or effective government program for such re-sensitization. For every American soldier killed there are 16 wounded comrades—an unprecedented number of people surviving, many of whom have suffered

severe physical and mental wounds, with many new kinds of brain and other bodily and emotional injuries multiplying. These injuries and their moral consequences will have a harmful effect on the lives of veterans' children and grandchildren. Returning, re-called, and returning again and again, these soldiers are not only traumatized, but also dangerously re-traumatized, in turn traumatizing, re-traumatizing, harming, or even killing others or themselves.

The trauma for Iraq and Iraqis is, of course, far more massive. 80 percent or more of children in Iraq suffer post-traumatic stress, joining the majority of Iraq's traumatized population. Countless Iraqis have lost their lives, others survive wounded, impoverished, or having lost their close ones, friends, or community ties; many seek uncertain and traumatic refuge abroad.

Many soldiers (and often members of their families) are critical of their early decision to agree to military service, often made under confused circumstances, while still under age or in high school. Naïve, uninformed, or impulsively acting out of patriotic passion, they are often allowing themselves to be crassly manipulated by government propaganda or promises that later go unfulfilled, assuming they have little or no choice because of poverty or lack of better prospects. In the light of what they have painfully learned about this war, they, too, may feel part-guilty and part-innocent about their service.

Half-guilt and half-innocence has also entered our daily life with the prodigious penetration of newspaper and television imagery of the war. Hegel notes:

Reading the newspaper in early morning is a kind of realistic morning prayer. One orients one's attitude against the world and toward God [in one case], or toward that which the world is [in the other]. The former gives the same security as the latter, in that one knows where one stands.[10]

Hegel's observation that the reading of the morning paper is a modern substitute for one's morning prayer is not without validity today, and reinforces the foggy atmosphere of our pseudo-ethical and pseudo-political life, a life of half-guilt and half-innocence, half-convenience and half-inconvenience, half-responsibility and half-irresponsibility. The physical, mental and moral injury, the lethal damage and suffering inflicted on others in Iraq and Afghanistan, are turned into 'parareligious' media representations disseminated by the media, in the form of an avalanche of false icons and pseudo-holy images. This spectacle of human tragedy and trauma, which we also ponder on the radio and over the internet, provides a pseudo-metaphysical or spiritual assistance in our confused life.

This comes at the relatively easy price, the price of 'feeling empathy'. As long as we somehow establish a bridge of empathy with other people, or, more precisely, with their icons, we feel that we are worthy of being members of the human family, and thus feel better about ourselves— the 'redeemed'.

Based on hope, prayer and a 'parareligious' addiction, this morning empathy and desire for at least partial redemption is soon over, with the realization that the real people behind the iconic images have never chosen to be martyrs or saints, to save and redeem others and us. This, however, only lasts until the next morning, until, fortunately, a new newspaper and front-page icon arrives to soothe our spirit again.

Although made long before the advent of color-photographic icons, Hegel's observation is still acutely accurate today. Current advanced technologies of image reproduction only add to the power of Hegel's "realistic" prayer and, as in The New York Times or The Boston Globe, front-page altars and large-format altarpieces offer the perfect holy image or icon.

This sense of living in a state of part-innocence and part-guilt comes also from seeing oneself as both survivor and potential target of the terrorist attack: as one who has a legitimate right to self-defense against enemies from abroad, and one who could support the strengthening of the country's internal security, the reinforcement of its borders, and the action against illegal immigrants, on the grounds of infiltration by potential 'terrorists'.

CULTURAL AND POLITICAL ISSUES

This state of half-guilt and half-innocence is a social symptom, which should not be perpetuated as a frozen 'moral' condition.

Americans are generally a society of pragmatic spirit, of positive and proactive attitude and approach.

Although now, after September 11, we are part of a global, politically divided, and ethically perplexed society, feeling unintentionally implicated in the government's crimes at home and abroad, most of us also feel the need to move forward, beyond mere study, discussion and reflection. This dilemma should become the starting point toward a new, pragmatic, both constructive and deconstructive but above all proactive, political project. The ethical fog in the political limbo of our post-September 11 situation can only be lifted step by step, under new transformative and creative conditions.

Yet re-naming, philosophically re-designating our city, even in as profound a way as Levinas has done, can only be the first step. Today, as in biblical times, in order to be convincing even in concept and metaphorical dimension, such a theological urban project needs to be extrapolated into a symbolically and operationally detailed spatial and administrative plan.

Levinas was not in a position to offer a more detailed 'design' for a contemporary City of Refuge. Unlike Moses he was not an urban planner. His Benjamin-like re-actualization of the Cities of Refuge is most inspiring, yet its contemporary social program, and its urban and architectural design, is still incomplete.

For the existing city to become ethically, socially and politically a truly operational City of Refuge, the September 11 memorial proposed here would need to be understood and undertaken as a substantial urban project.

Before we attempt to immerse ourselves in the task of navigating through precariously shifting currents of the programmatic and design process, we must recognize the key problems and issues of the present day, issues not taken into account by Levinas, as well as tasks and problems that, to our knowledge, were not addressed in the original biblical designs and the subsequent Talmudic discourse.

One would hope that the September 11 memorial, through helping the city to be an operational City of Refuge, will, in some distant future, contribute positively to the situation in the world, and will pave the way for a less stratified and more egalitarian social structure and economy.

Its utopia is based on the assumption that its effective operation will make it obsolete.

But if this is to happen, the memorial's design, program and organization, will need to take into account the existing social reality, the often harsh reality of our city's present-day urban and cultural geography. Our new City of Refuge, our protective and educational exile, will not be protected from our cultural or economic class divisions.

OUR INEQUALITY IN THE EXTENT TO WHICH WE ARE PART-GUILTY AND PART-INNOCENT

New York City's population now consists of 60 percent of first-generation immigrants.

These who live in poorer city districts, less protected, but nonetheless protected, are, too, part-guilty and part-innocent, but in a very different way than residents within easier reach. They may be, as Levinas might say, "subjectively guilty", guilty of not being on the site of the deadly tragedies in their old countries, of not directly helping their families in survival and struggle, even if they are "objectively innocent" in terms of a decision to emigrate, which is often beyond their control.

These double exiles (as most of them are already exiled as immigrants) may be subjectively guilty of existential choices that are in conflict with a religious family upbringing, while objectively innocent, as when they offer their families abroad great help. Some immigrants and their children may perhaps feel, or be treated by others as guilty of enjoying, even endorsing Western, liberal, or as Levinas calls it, "Greco-Roman civilization", instead of joining the "avengers of blood" in attempting to attack the perpetrators (some of whom, intentional or not, may live next door in richer urban neighborhoods). For that reason, they may themselves be afraid of "avengers of blood"

who might infiltrate their less secure city districts and attack them as 'traitors'.

On the other hand, some of New York's most privileged residents live in a more or less extensive, but still exclusive, safety zone, within safe districts and protective urban enclaves. They enjoy more protection than anyone else. They are not afraid of a potential attack by hostile redeemers of blood, whether coming directly from foreign lands or through the less privileged and protected sections of the city itself. These, living in the richest city districts, most secure in their self-protection, represent a special breed of mixed guilt-innocence incomparable to others. They are subjectively most innocent but objectively most guilty. They are guilty for knowing less, and not wishing to learn more about their unintentional implication in the world's misery.

Some city residents may not be seen as simply unintentional killers. They are both intentional and unintentional manslayers: intentional, when fighting or consciously supporting the killing of insurgents and terrorists, and unintentional, when remaining unwilling and unaware contributors to the murderous and killing policies and conditions in the global South and in our poorer city districts.

Some of us are half-guilty and half-innocent, but some may be more than less guilty—much less than half-innocent.

It is clear that separated as we are, we bear and bring to the City of Refuge and to its central place—the September 11 memorial center—very different categories and 'proportions' of guilt and innocence. This may suggest projects aiming at both an intellectual and passionate recognition and confrontation of the reality of these separations, historical, religious and social. The memorial project will need to assure in-depth study while inspiring and aiding gatherings, debates, and discussions between and among alienated groups in exile.

We will be forced to ask ourselves many new and risky questions, for ethics always involves risk, but "risk worth taking", as Levinas says.

TOWARD A DEMOCRATIC AND AGONISTIC MEMORIAL

One must assume that a less violent, vengeful, and terrorist world cannot be envisaged without a more dynamic form of democracy. According to Chantal Mouffe, such a form can be provided by an agonistic model of democracy, a model based not on agreement but on non-violent disagreement, a democracy that would endorse both passion and social inclusiveness, while questioning the validity and wisdom of consensus, and encompassing a creative dissensus where 'adversaries' take the place of 'enemies'. For Mouffe, civilized and rational agreement—as in the deliberative democracy promoted by Jürgen Habermas—is usually reached at the price of social exclusions. Agonistic democracy must create inclusive conditions for a dynamic open discourse that

exposes and challenges, rather than hiding and dissolving the most burning and inconvenient issues through compromised solutions.

I believe that such a radical democratic agenda needs yet another kind of agon, an agon of memory—a space and place that encourages and sustains conditions for the articulation and exchange of contending voices and experiences, a place for an agonistic telling and hearing of memories, for memory as political, ethical, artistic and therapeutic discourse, for a public contest of memories, for both challenge and healing.

As it was suggested earlier, the September 11 memorial should be a place, even a laboratory for such agonistic and ethico-political memory-work. It should be a place for a multitude of converging memories, for memories that challenge, question, supplement and support each other, for memories of suffering, of revenge, of plans and actions, and of harm suffered and inflicted; for the recollection, public acknowledgment, examination and discussion of misguided deeds, deeds that have caused, or may have caused, intentional, or unintentional harm.

It will need to secure places for gatherings, workshops, debates, discussions, official, private, or semi-private, a space for cultural events and other activities and projects, both preconceived and spontaneous. Many of these will aim at preparing participants and assisting them in finding their own ways of engagement in social actions domestic and abroad.

The goal is to bring discourse to a critical saturation point, to a convergence of so many points that it is impossible to maintain a foggy state of half-guilt and half-innocence, an ethical and political submersion in ideological fantasies.

The agonistic nature of the memorial could be explained in terms of concepts drawn from Michel Foucault, Claude Lefort, Chantal Mouffe, as well as from Levinas and the philosophy of history of Walter Benjamin:

• Ancient Greek democracy was built on the fundamental citizens' right to *parrhesia*, open, free, critical, frank and emotionally charged speech, which takes the risk of challenging the authorities' wrongdoing, and is based on one's own lived experience—"fearless speech", as brought to our attention by Foucault. The memorial center should encourage such public practice, and further provide conditions for open, free, emotionally charged, critical and fearless listening.[11]

• In such an agonistic memorial the voice should be given both to the testimony and opinion of those who are not in a position of power, to those who belong to the Levinasian category of "Saying", and to the testimony of those who are powerful—the "Said". It should encourage the conditions under which the weak "Saying" can become (even if for a moment) a powerful, "Justified Said", and provoke the powerful "Said" to understand, and even take the position of, the "Saying".[12]

• The September 11 memorial should be open, as Walter Benjamin would have it, to the "vanquished" who may critically project their memory, their "interruptive tradition" onto the "patrimony", the "linear history" of the "victors"—whoever these victors and vanquished may be or think they are.[13]

• In Friedrich Nietzsche's words, the memorial must be open to quarreling memories and histories—to those of "critical history" and to those of "monumental history"—in order for them to question each other, even self-critically learn and recover from each other what they have forgotten, what they take for granted, and perhaps what they should forget as well.[14]

• As trauma theorist and therapist Judith Herman has reminded us, memory is essentially the act of telling a story. The September 11 memorial, as a place open to agonistic memory, must provide the conditions for the transformation of dry and "factographic", matter-of-fact post-traumatic testimonies into healthy post-traumatic memories, charged with the emotion and expression of the speaker, while inviting emotional charge on the part of the listener.[15]

• As a public space the September 11 memorial must, as philosopher Claude Lefort says, "remain empty" ("un espace vide"), and must not "belong to anyone", but be open to all those who wish to "recognize each other in it", who can "bring meaning to it", and who wish to disseminate "issues of right", expanding further these rights to others.[16]

QUESTIONS REGARDING THE LIMITS OF THE MEMORIAL'S INCLUSIVENESS

Can a person overwhelmed and indoctrinated from very early childhood with religious and nationalistic ideologies, tribal 'laws', ethnic 'martyrologies' and harsh cultural norms of revenge, a potential "avenger of blood" him- or herself, be pronounced half-guilty and half-innocent and be admitted as a co-resident of our City of Refuge? Specifically, after having refused a tribal duty of blood-vengeance, should not he or she, fearing bloody retribution coming from within the family, tribe, nation or ethnic group, have a right to refuge? After all, in such a case, the act of not carrying out blood-vengeance may qualify as a version in reverse of a crime, one that itself deserves blood-vengeance.

Another question: when some zones of the world are finally free, or mostly free, of "avengers of blood" and terrorism, (and sufficiently free of our unintentional deeds), can our September 11 memorial become a place for a new kind of truth and reconciliation, a project focusing on half-guilty and half-innocent testimonies coming from those parts of the world and from the parts of 'ethnic' districts and populations that are relevant to them?

Will former "avengers of blood" and former unintentional manslayers be able to apply for admission to such a refuge project? If so, under what conditions and on what terms would it be

permitted or encouraged to come to our City of Refuge and our September 11 memorial?

The question of hypocrisy: all of the inner antagonisms brought into the exile by the residents coming from West–East, South–North and possibly even by the potential or former "avengers of blood", may need to be put on a new constructive-deconstructive critical agenda at the memorial.

Levinas speaks of the hypocrisy of our cities of the North when condemning the anger and 'barbarity' addressed at our Greco-Roman civilization from the cities of the South:

And while it is a necessary defense against the barbarity of heated blood, dangerous states of mind, and threatening disorder, is not civilization, our brilliant and humanist Greco-Roman, our wise civilization—a tiny bit hypocritical, too, insensitive to the irrational anger of the "avenger of blood", and incapable of restoring the balance (between our prosperous North and the impoverished South)?[17]

There may be different histories and different doses and kinds of hypocrisy on the part of residents of the cities of the South, also proud of their own great civilizations.

Can antagonisms meet and recognize each other in our September 11 memorial, and do so in an agonistic way, with passion, but allowing logos to meet eros, or *eris*, 'strife', without spilling blood?

QUESTIONS REGARDING THE APPROPRIATENESS OF ANALOGY TO THE WOODCUTTER'S CASE, AND FURTHER OBJECTIONS

Let us take a closer look at the Levinasian re-actualization of the biblical woodcutter's case: one could easily say that the biblical analogy may be inappropriate, even disrespectful, to the victims of September 11 and the surviving New Yorkers. Others may point out that in the biblical example, the woodcutter was not killed, nor did he lose a loved one. Because of this difference, one might ask, is not the World Trade Center attack a most inappropriate occasion to focus on and deliberate our objective half-guilt, or subjective half-innocence? We should instead focus, so the argument goes, on those who are, objectively, fully guilty: on the intentional murderers, driven by their blood-thirsty ideologies to become terrorists themselves. The biblical analogy can be easily accused of blaming the 'victims' (blaming ourselves for what the perpetrators have done), while acting as an apology for the 'terrorists' and their mass murder.

· First response: The fact that so many among us became victims and remain traumatized survivors does not mean that we should not learn a political and ethical lesson from our losses for the future. Those who lost their lives deserve commemoration through our desire to make the world better, and not through a perpetuation of acts and wars of revenge.

• Second response: The Levinasian analogy may seem inappropriate only because the woodcutter's unintentional act of manslaughter—caused by a disregard of the impact of his or her actions on others—occurred in a straightforward way, and was not immersed in a complex set of political, social, economic, and cultural circumstances. His loose axe-head did not have a destructive and deadly impact in foreign lands, did not fly over the city to strike segregated and economically alienated urban strata, and affected only one person, not millions. Finally, the injury or death of the victim occurred without substantial delay in time, and could not be distorted or omitted by media coverage.

• Third response: Neither our ethical and political self-examination, even self-criticism, nor a historical analysis of our mistakes and ignorance (which may have had a negative effect on other parts of the world and, to some extent, on parts of our own cities) has anything to do with justifying barbarian actions against us from without or within. In other words: discussions, even explanations, of the conditions behind the crime must not be confused with explaining away—even with the inexorable logic of cause and effect—the crime itself, even less its justification or, worse, apology. Ours is an imagining of and investigation into the grounds of crime, into the historical, social, ideological, and political processes that led to it. Nor can we endorse, in reverse, self-blaming and narcissistic fashion, the "eye for an eye", Bin Laden principle of "they have done unto us as we have done unto them". Nothing should justify shortcuts in our or their thinking.

The principle and mission of the Cities of Refuge was also to make a distinction between the blood-thirsty tribal "eye for an eye" talion law, and a new, civilized, system of justice and ethical life. This is the passage from "repressive" to "restitutive" justice in the development of "organic", rather than mechanical solidarity, in the words of Emile Durkheim, one of the founders of modern sociology, and the first to lay down the lineaments of modern critical categories for social action.[18] Our own 'after-the-fact' critical self-reflection and sociopolitical self-education does not justify the fact of the crime committed against us.

The 'after-the-fact' refers not to the 'fact of the World Trade Center bombing' but rather to 'facts' that occurred, earlier, in another time, somewhere else and over a long period—to facts in which we, or our ancestors may have been implicated. The bloody terrorists' 'interpretation' of these facts, which took the form of a September 11 massacre committed by them as an act of massive and collective 'vengeance', is the sole responsibility and fault of these assassins. In sum: our possibly unintentional harmful acts have no symmetrical relation to the intentionality and full guilt of the perpetrators—of the crime of the self-styled "avenger of blood".

• Fourth response: Pragmatically speaking, our intellectual shortcuts, our ethical and political blindness, may only increase the possibility of causing unintentional accidents, and in some indirect way invite regional, even global anti-

Western anger in favor of launching more terrorist attacks. Conversely, our complex ethico-political thinking, perhaps in itself incapable of preventing potential attacks, may at least become part of a wider attempt at eliminating the conditions that provide fertile ground for the barbarians to draw resources and support toward their criminal murderous acts.

• Fifth response: There is no evidence in the Bible that the Cities of Refuge were ever attacked, with the exception of one case when one of the exiles was killed by an "avenger of blood", after foolishly stepping into the open City gates. Yet, surprisingly, even shockingly, the "avenger of blood" has succeeded in penetrating our city twice, and in the same symbolically and socially strategic place—the World Trade Center— and has managed to kill thousands.

One might then wonder how the population of those biblical Cities would have responded if a massive attack, of the magnitude of September 11, had taken place then? Would they have created spontaneous, commemorative events and displays, supplemented by a massive forum or public debate and critical analysis, a complex (working-through) act of memorial similar to the one New Yorkers undertook five years ago? Possibly (and of course hypothetically), I would say, yes, they would. With their newly raised consciousness, a result of their intense ethical study, they certainly

could have done so, perhaps in an even more complex and informed way than we, myself included, have done.

GENERAL OBJECTIVE OF THE MEMORIAL

The word memorial is related to the word *memento*, a thing—or more precisely a command—to mind and remind. A memorial's function is not only to commemorate past events, but also "to serve to warn, or remind, with regard to conduct of future events". A memorial may be something more, something other than an object or site; it may be an event, even a working institution or organization that simultaneously mourns the tragic events of the past and minds and reminds us to be vigilant in the future, to take action so that certain events never happen again. A memorial demands memory-work and active agency, an action.

The harm and damage done to others and to ourselves must be historically and critically remembered and re-remembered, and this must be done in a way both discursive and analytical, agonistic and socially inclusive. We must first critically and historically analyze and debate every dimension of the half-guilt and half-innocence evoked and inscribed in our consciences by the horrors of the September 11 attacks and their aftermath. And then we need to move forward, beyond mere study, discussion and reflection, to

assume collective responsibility for doing something about it.

How can the memorial be designed to secure, inspire and assist in such an agonistic and inclusive program?

TASKS

Honoring the meaning of the word "memorial" (and its etymological origin), the September 11 memorial should be a place of study, though not exclusively so. Parallel to this, it should be a place of inspiration and should enable the participation in projects in which we can engage and make a positive difference, especially in areas where 'we', as a group, population, society or nation may have "caused foreseeable accidents (in the world) in which there was some degree of negligence involved".[19] The September 11 memorial should be inclusive and open to all residents of the city, including refugees, immigrants, documented and undocumented activists, politicians, students, as well as all our present day 'Masters'—intellectuals from cultural, teaching and research institutions such as curators, critics, analysts, professors, researchers, and others.

To achieve ethical and political clarity as a contemporary proposition, its functional and symbolic program, its social organization, its design, even its name will need to become the subject of inclusive and heated discussion, public examination, criticism, careful development and realization.

WHICH LOCATION AND WHAT SYMBOLIC FORM?

But what urban structure shall we design for examining and questioning our own and each other's pasts and presents, all those fictions of ourselves, the idealizations, ideologies, and 'official' identities—in order to 'undo' the way we are or rather, the way we have become? How should a memorial allow for critical and philosophical study, and for open and informed discussion to advance the political, economic, cultural and historical understanding of the September 11 and post-September 11 catastrophe? Should we think of designing a central, multimedia and interactive sanctuary and a massive gathering place for such purpose?

What sort of design project would be effective in both protecting and inspiring the process of questioning and undoing the stability and solidity of our idealized notions, structures and practices? Should we think of designing a philosophical urban laboratory, or a multitude of laboratories, for such a deconstructive-constructive, existential, political, cultural and psychoanalytical project? Should these laboratories be communication networks, stationary structures, mobile units, or monumental gathering spaces? Should the proposed memorial commemorate and engage

both traumatized US soldiers and the families affected by that trauma? Should Afghan and Iraqi victims and survivors, both soldiers and civilians, be included in the memorial's program and design? Should such a working memorial include the domestic victims of Homeland Security repression?

Monitoring the unfolding dynamics of the world situation will need to be another part of the memorial's agenda. The memorial institute should be home to an organization monitoring acts of terror and violence, both symbolic and real, around the world, keeping a close watch for the symptomatic signs of material and psychosocial conditions that foster revanchist tendencies. It will track and analyze these conditions and events, recognizing in them possible harbingers of future strife. It will also monitor conditions of freedom, or the lack of it, throughout the world, tracking developments, both positive and negative, related to the rights of the citizens and non-citizens of different nations. Events that might have been monitored in the past include the Serbian and Albanian nationalist movements in Kosovo that arose in the 1980s, and the hate speech and low-level violence that took hold in Rwanda in the years leading up to the Rwandan genocide. In both cases, explicit threats and incremental curtailing of human rights anticipated actual violence.

The September 11 memorial should be a working space of proactive engagement which will allow the visitor to re-conceptualize the past by projecting onto it questions about the present and the future. It is a space that exists to ask and provoke questions. What is happening in the world? What are some of the political and cultural consequences of 9/11, both in the US and the world? What might we do, and what are we currently doing, to ensure that certain events will not happen again, here or anywhere else? What have we not been doing to prevent it from happening in the first place?

The organization that monitors world conditions will be linked to other organizations that are taking action to affect change. The visitor to the memorial site, having gained some sense of "what is happening", will be encouraged to ask the questions: "what is being done?", "what must be done?", and "what can I do?". Organizations that are taking action provide a possible answer, an outlet for pursuing concrete change in the world, and visitors will be given an opportunity to see what they do, and to contribute to or join these organizations.

The architectural structure of the September 11 memorial should be easily accessible and visible to all New Yorkers. Let us envisage it as a structure to be placed not on solid ground but on water, on unstable ground, one connected through the ocean to stormy lands overseas, the lands of troubles in which we may be implicated—the symbolic and historic connection with the world of our unintentional global deeds and potential points from which the new intentional and unintentional exiles may come.

The September 11 memorial should take the external form of a globe-like structure, floating, and slowly rotating, anchored in the harbor, somewhere between the site of the World Trade Center, Statue of Liberty, Ellis Island, Governor's Island, Battery Park, New Jersey, Manhattan, Brooklyn, and Staten Island.

In this way, the memorial will be symbolically linked to, visible from, and look upon the Statue of Liberty—which itself calls to and welcomes the "misfortuned and mistreated of all foreign lands"—and upon Ellis Island—a former immigrant gateway to New York City, immigration asylum, and now immigration museum.

THE PROGRAM

The memorial will be made up of seven major programmatic components:

• First component: facilities for historical, philosophical and cross-disciplinary study of the conditions and forms of terrorism and terror, such as archives, multimedia and other facilities for research, learning and teaching, and spaces for smaller and larger group discussions, meetings and conferences.

• Second component: a central information resource and communication facilities for the public to connect with organizations and groups in the US and throughout the world, a resource especially designed for those wishing to engage in proactive social, political, economic and cultural

work, to help in the process of ameliorating existential and political conditions in the world, while preempting the potential growth of terrorism and an interactive multimedia facility with real-time links to those working in the social and political sphere will need to be designed.

• Third component: a 'situation room' displaying the changing map of zones negatively affected by the global and regional presence and policies of the US and other cultural and economic powers—zones that may become a fertile ground for the growth and dissemination of terrorist ideologies and actions.

• Fourth component: an open agora, a central forum for public debates, with arenas for cultural and artistic projects and events and prerecorded and real-time spectacles. Among other aims, they may provide cultural and political links between New York City and other cities, public places, events and networks in the less understood parts of the world.

• Fifth component: a legal aid, social work, political advocacy, medical care and human-rescue program. One example of an outcome for this facility and program could be the freeing and compensation of those who have been mistaken for terrorists and unjustly detained, deported, or imprisoned, whether American residents or foreign visitors. A post-traumatic research program and a medical clinic for survivors of 9/11 and of US military and Homeland Security actions may be an important part of this facility.

• Sixth component: urban headquarters, a coordinating media and information resource and archive for urban commemorative and intellectual projects, including those supplemental to the memorial center. The September 11 memorial will, of course, be a major resource for the city. At the same time, it will embrace the city itself as a vital resource, learning and drawing inspiration from it. Through its central facility it should be linked to many smaller sites and organizations that function as symbolic and practical supplements to existing urban sites, institutions and organizations. These may include: City Hall, convention, trade and shopping centers, train and subway stations, airports, major hotels, public libraries, schools, universities, museums, art and cultural centers, art and science foundations, social advocacy or assistance organizations, hospitals and clinics, mosques, churches and synagogues, war memorials as well as civic monuments and other symbolic edifices and structures.

• Seventh component: a global and local media broadcast facility including television and radio studios, press, world wide web and electronic media, as well as all traditional forms of publishing and distribution.

FINAL ARGUMENT

As a working memorial, the memorial must bear careful and analytical witness to new events, to responses to them, and to events that follow. Memory is a working process. Each time a new attack or act of vengeance takes place, it must be projected onto our commemoration of 9/11. We must critically infuse the past with the present, as if the past has always been pregnant with the seeds of the present. This will allow history to remain dynamic and move forward. It will help us to actualize the past and, in turn, will make the past useful for the future, a future wherein generations with no direct remembrance of 9/11 will continue to be informed, visionary, critical, proactive and practical.

New York City is a reluctant, but nonetheless vital part of the US, and the US, for better and worse, has an enormous economic, environmental, cultural and political impact upon the world. Decisions made in Washington and on Wall Street, whether careless or well-considered, affect the lives of millions of people across the globe. Levinas may be right in saying that the prosperous cities of the global North (New York City being one of the most prominent examples) have economies that are intertwined with—if not indirectly or even directly built upon—the miseries of the cheap labor of the cities of the global South, the *maquiladora* assembly factories along the borders, immigrant sweatshops, the undocumented labor force (half a million in New York City alone) in our own cities and in our suburban and rural plantations.[20] Even if unintentionally, we may be living in half-conscious Cities of Refuge, half-ignorant and half-informed about our devastating global deeds.

Given our economic and cultural prominence, should we not strive to further educate ourselves about our empire, to gain further awareness and understanding of the impact that it has upon the world?

Perhaps we should not think of our city as the City of Refuge from but as the City of Refuge for: for both study and practical work on and for the new global reality, for confronting our ignorance, blindness and numbness, and, finally, for intelligent contributions toward healing the world's ills, and toward the vision and practice of a 'non-catastrophic' progress.

In the proposed memorial, through an act of ethical imagination, the victims of the September 11 bombing may not only be remembered, but 'seen', as if they were watching and critically evaluating our actions today—witnesses to our proactive work towards a better human world.

As a metaphor and practical proposal, the September 11 memorial may turn out to be an indispensable urban supplement to New York City, the supplement that may aid and inspire its transformation into the intentional City of Refuge.

To testify to and bear witness to the event may be essential for traumatized survivors, those who suffered terrible personal loss in the World Trade Center attack and still cry out—though this is not necessarily the only possible path. To heal their traumatic wounds they may choose to work toward a more conscious and a less inhuman, violent and vengeful world.

AFTERWORD

THE INTELLECTUALS' HALF-GUILT AND HALF-INNOCENCE (A SELF-CRITICAL NOTE)

Citing Talmudic sources, Emmanuel Levinas reminds us that not only those exiled, but also their teachers (Masters) may have been asked to move to the City of Refuge to help their former pupils in their study. Implicated in his disciple's unintentional deed, the teacher, too, may have been pronounced half-guilty and half-innocent, for providing an ineffective professional or ethical education, or deciding to teach a student who was not worthy of his pedagogical effort. As Levinas reminds us, there is an old Jewish dictum that says, "Let no one teach the Torah to a disciple that is unworthy."

The Master must take responsibility for and bear the consequences of the disciple's ethical potential (or lack thereof), his or her responsibility or irresponsibility. In an extreme case, or in the heat of Talmudic debate, some scholars (R Johanan among others) have even discussed the possibility that the laws governing the Cities of Refuge demanded the banishment of the Master's entire school or college (*Yeshivah*).

Intellectuals who are not challenging their institutions, whose critical presence is publicly absent and who do not contribute to the larger

intellectual public sphere are (less than) half-innocent and (more than) half-guilty of the miserable and hopeless conditions of those less fortunate and prosperous.

Many of us, some of whom artists—members of the intellectual class, a class or caste that assumes a privileged position of public trust and claims itself the most educated and 'intelligent' part of society—navigate through our lives under the guise of making so-called common-sense decisions, wise and 'existentially necessary' choices, that, in truth, often aim at the consolidation of our careers and the protection of our positions. These passive choices are made without much regard for their impact on the perpetuation of the miserable existential and political situation of those incomparably less secure, free, respected and influential than us.

In this way, more than half-guilty and less than half-innocent, we live half-awake and half-asleep. With one eye half-closed and another half-open we only see the foggy and blurred reflection of ourselves in the mirror, and of the world around us on television and in newspapers.

While one eye may be even more than half-open to the legitimate problems of globalism and other larger environmental and political matters like social and cultural justice and injustice on our planet, our other eye is too often even more than half-closed to the inhuman situation and conditions of life of other people, whether living far away, close by, or even next to our doorsteps, across the street, or a block away from us; all of those who, without documents and access to any rights, produce, in sweatshops and plantations, cheap goods for us, who provide care for our grandparents, parents, and children, who clean our homes and offices, who work in the kitchens of our favored 'ethnic' restaurants, and finally, to those who, with no access to lawyers or their families are unjustly deported or locked in virtually secret Homeland Security detention centers here and abroad.

Our constitutional right to the 'pursuit of happiness' too often overrides our ethical obligation to help those less fortunate than us, so that they may enjoy the same rights. Those among us who have more access than others to the constitutional First Amendment—through the enjoyment of their 'academic freedom' and of their well-established and secure positions of generally 'risk-free,' now 'nearly risk-free' professorships with tenure—are usually not inclined to speak or write openly, to address the broader public about the unacceptable existential, social, and political situation of those who have no right, opportunity or ability to open up and speak out in the open.

Our access to the constitutional rights, our First Amendment, our intellectual *parrhesia*, far greater than others', is not only a right, it is both a public expectation and our ethico-political obligation. It is in fact a duty to take a critical position, a risky stand in pursuit of enlarging

access to rights for others—an obligation to secure better political and cultural conditions and greater public consciousness to help these 'others' in asserting, as Hannah Arendt has said, "their right to rights".[21]

As Bertolt Brecht would say, in our semi-actions, pseudo-actions and inaction, we do not reinvent our institutions to make them face a troubling social and political reality, and make them do something about it.[22] Instead, we renovate these institutions and in fact perpetuate their continuing passivity and their own half-guilt and half-innocence—their objective innocence and subjective guilt vis-à-vis a world that lives in need of their help, and justifiably expects their help.

The way we pretend to be "organic intellectuals" who deconstruct and transform the world from within, and justify our sinecures as a step in the necessary "long march through the institutions", the way we falsely cite Antonio Gramsci and Bertolt Brecht as our prophets, with whom we have practically nothing in common, are also the ways of our one eye half-open and the other half-closed, of our objective innocence and subjective guilt.[23]

THE CULTURAL ECONOMY OF SILENCE

The reelection of George W Bush has weakened the self-confidence, courage as well as the critical capacities of vast sections of the middle class, and with them the media, universities, museums, cultural institutions, etc..

In cultural centers and in academia it is in 'good taste' today to imply that one may be against domestic and foreign wars, and the policies and measures enforced by the present government—yet only in private or confidential meetings. In public, and above all in one's projects, one must remain 'neutral', 'humanistic', and 'universal'—anything to avoid what could be called "political". The political climate ignited by fear of terrorism controls our thinking. Collectors, directors, curators, gallerists, art professors, and artists themselves live in self-censorship and with the dubious outcomes of their common-sense choices made in the name of economic survival and aesthetic 'sophistication'. (They say political art is too simple; that artists should not be "preaching to the converted"; that "in our hearts" we are all against the war anyway, so let's keep quiet to survive; that it's only a year before 'he' is gone.)

Boards of trustees, corporate and individual sponsors, and state and city political support have indirect or direct connections with the interventions of the US government. Today, one should not take any risks by messing with these interests: the new managerial style of cultural and academic institutions advocates this in quite open way.

It is clear that the art market-driven cultural economy alienates us from the collective or

coalition-based oppositional practice of the 1960s, 1970s and 1980s. Emphasis on an individual artist's *oeuvre* (demanded by the market) and the fashionable aversion to any kind of socially focused critical art (a 'negative' term, if not a curse) is a dire precursor for the lack of any socio-aesthetic action and movement.

Many people say that the idea of political art is *passé*, which sounds like saying that criticism and critical thinking, protest, and opposition to right-wing, nationalistic and imperialistic ideology are *passé*. The political art of the past cannot, of course, make sense for the present. Another form will need to be invented now and in the future. What was good yesterday may not be good for today, what is good today may be not good for tomorrow (a Brechtian thought). Why, then, have we been attempting since the 1990s to bury all kinds of political and engaged art? Why haven't we just gone ahead to invent new ones?

Why can we not capitalize on, and critically re-actualize the past public engagements of Emma Goldman, Michel Foucault (including his participation, often as a leading figure, in political protests and gatherings), Gilles Deleuze and Félix Guattari (with their call for "new productivism" in philosophy, and the latter's experimental psychiatric clinical practice), Diego Rivera, Leon Golub, and among the living, Barbara Kruger with her intellectual-activist practice, Étienne Balibar, Noam Chomsky (and so many of his academic friends and adversaries active in the media, writing for newspapers passionate philosophical commentaries on social, political and artistic matters unfolding daily)?

TO UNIVERSITY PROFESSORS

There are many of us who do not reprimand our colleagues for their inactions and their general passivity. Others are blaming staff and faculty meetings for being boring while never introducing disturbing and definitely less boring 'outside' matters to them. Many of us fail to call our academic institutions to take a public stand; we fail to take up our political duty and intellectual responsibility to critically respond to our own passivity, to a safe way of doing business, research and teaching, and to the wrongdoings of governmental and corporate authorities, politicians and institutions—local, regional and municipal.

We do need to write and speak to and within our academic world, but we should also remember that our students listen to us as long as they remain influenced by and study under the pressure of our intellectually autocratic and bureaucratic university system and are under our professorial power. We should be present inside and outside of academia to sustain our work for and with younger generations.

Let us engage in speaking to larger groups, in public and not only in universities, at lectures, public rallies, protest marches, let us write letters to the editors in mainstream media and

contribute to the vast number of alternative media networks! With our critical knowledge and our research experience we can help to make them powerful *parrhesiastic* fora. Let us take part in the organization and leadership of social movements small and large.

What happened to the intellectual responsibility and ethical integrity of university professors? How do we make sense of our academic freedom and of our tenured positions? Is this truly a freedom for or only a freedom from? Is this power of having a quiet 'sinecure' or a power of having a well-entrenched position from which to fight?

Some of us do not have the talent or capacity to be public intellectuals, but so many of us are so skillful in speaking and addressing others in academic gatherings and in lectures and seminars.... Why are we only outspoken there, only on those occasions?

Are we not (less than) half-innocent and (more than) half-guilty, and a bit conservative, when we say "they" (of students as one example) protest something, but do not propose any alternative? One does not need to propose alternatives to protest. This is, as Foucault said, "bureaucratic talk". To all who protest: we must continue protesting, denouncing, and exposing what is wrong, and do so in articulate and demanding ways, and we must provide our intellectual support and position in this process.

Protest, when it is articulate, is already action pro-change, for in the word 'protest' *pro* is

connected with *testi*, 'witness'—the witness who prophetically announces and denounces wrong. As Benjamin would have said, the prophets come from the "vanquished", not from the "victors", and they always "interrupt history" with the "revolutionary intuition of the present", to transpose the "personal" into the "historical".[24]

We are more than half-guilty and less than half-innocent when we refuse to address a broader public outside academic, administrative, or research institutions and refuse to share with this public our enlightened views, accepting to do nothing in the public domain, knowing that due to the ignorance of the populace misguided voters may be soon reelecting a government that will be unacceptable by any democratic standards.[25]

We are more than half-guilty and less than half-innocent when we blame everything on government wrongdoing, while not seeing our own existential and political inactions as a factor that may be contributing to the very existence of such a government.

We are more than half-guilty and less than half-innocent when we cry over the decline of the 'public intellectual', and complain about our absence in public and in the media, while doing nothing to revive and reinvent our critical and analytical presence in the public domain.[26]

The self-critique of student passivity and self-insulation from a troubling wider world,

and of their "imaginary relation to their real conditions of existence", was well articulated in the renowned manifesto "On the Poverty of Student Life" (*"De la misère en milieu étudiant"*), originally published in 1966 by the Strasbourg Student Union.[27]

In the context of our new frightening political reality, in which our minds are more and more foggy and passive and our oppositional reactions and critical thinking more and more relegated to the private domain, increasingly structured and governed by government propaganda and security measures, and in a time when tyranny is being born again from people's mindless acceptance and consumption of 'protected democracy', in this context, should we not write a self-critical manifesto to ourselves: "On the Poverty of Professorial Life"?

ART AND 'THE POLITICAL'

In the isolated academic environment it is almost impossible to break the wall of silence, reinforced by media and the cultural world, that separates two alienated populations: those who know what war is, and those who do not.

The silence of the cultural, academic and artistic worlds, along with media evasiveness and censorship, solidifies this wall. The fallout from the physical, mental and cultural trauma of this war will last for generations. The wall of silence, passivity, and ignorance must be dismantled. New tactical, cultural and media projects and

new kinds of working and critical memorials must be urgently developed with those who do know what war is, with veterans, their families, with survivors of the foreign and domestic "war on terror", with civilians of invaded countries, and with those who work directly with them.

If since the 1990s our objective has been to contribute to the political, rather than to politics, to the *polis* rather than the police, to that which is *potentia* and multitude rather than potentates, to revolt rather than revolution, to agon and dissensus rather then consensus, to democratic *parrhesia* and public interpellation rather than 'patriotic' or 'civic' responsibility, to nomadology rather than the state apparatus— let us then continue our effort in inventing 'art for the political'. Let us contribute to the political by disturbing the 'policing' practices of the governmental or the corporate authorities and agencies.[28]

Using the words of Jacqués Rancière, let us see the project of the political as an emancipatory project, in the sense of "disturbing the set system of social inequalities" by giving voice to those who are being excluded or segregated by fixed "hierarchies of knowledge" and culture.[29]

To contribute to the political means also to refuse to act as 'Masters' of others' emancipation.

We should act as if we were ourselves the disciples in the emancipatory process of others. Speaking again like Jacques Rancière, let's consider ourselves as the "ignorant

schoolmasters" ("*maîtres ignorantes*"), who create conditions for self-awareness, self-articulation, self-representation, and communication of the self, in short, for self-emancipation. There have been new and diversified methodologies developed in this direction by artists, artistic and cultural groups, collaborative networks, and coalitions.[30]

After post-structuralism, it is now time for self-reconstruction, toward new visions and constructions, political, social and cultural.

Envisaging and designing new, engaging, inclusive, agonistic, memorial projects must become part of this emancipatory agenda.

New York City
September 11 2001–2007

1. For the concept of "agonistic democracy", as a counterpoint to Jürgen Habermas' "deliberative democracy" see Chantal Mouffe, "Democracy, Power and the Political" and "For an Agonistic Model of Democracy", *The Democratic Paradox*, London/New York: Verso, 2000.

2. For the concept of "working-through" and "acting out" see Sigmund Freud, "Remembering, Repeating and Working-Through", 1914, and "Mourning and Melancholia", 1917, *Freud Reader*, Peter Gay ed., New York: Norton, 1989. Also Dominick LaCapra, "Conclusion: Acting Out and Working-Through", *Representing the Holocaust: History, Theory, Trauma*, Cornell: Cornell University Press, 1994.

3. Emmanuel Levinas, "Cities of Refuge", *Beyond the Verse: Talmudic Readings and Lectures*, Bloomington: Indiana University Press, 1994.

4. On the danger of "premature closure" see Bessel A Van der Kolk, Alexander C McFarlane, Lars Weisæth, *Traumatic Stress: The Effects of Overwhelming Experience on Mind*, New York: Guilford Press, 1996.

5. Moses, Stefan, "Benjamin's Politico-theological Model of History", in *History and Memory*, no. 1, Tel Aviv: Tel Aviv University, 1991.

6. For the psychoanalytic concept of ideological fantasy see Slavoj Zizek, "Seven Veils of Fantasy", *The Plague of Fantasies*, London/New York: Verso, 1997.

For a presentation of psychopolitics of xenophobia and xenophobic "projections" see Julia Kristeva, "Might Not Universality Be... Our Own Foreignness?", *Strangers to Ourselves*, New York: Columbia University Press, 1991, and also Krzysztof Wodiczko, "Designing for the City of Strangers", *Critical Vehicles: Writings, Projects, Interviews*, Cambridge, Mass.: MIT Press, 1999.

For the Levinasian concept of the "Other" see Emmanuel Levinas, "Time and the Other", *The Levinas Reader*, Sean Hand ed., Oxford/Cambridge, Mass.: Blackwell, 1989. Also for a discussion of the "Other" and the "Third" and their importance in the democratic process see Simon Chritchley, "Levinasian Politics of Ethical Difference", *The Ethics of Deconstruction: Derrida and Levinas*, Oxford/Cambridge, Mass.: Blackwell, 1992.

For a discussion of new proactive projects, see Richard Rorty, *Achieving Our Country*, Cambridge, Mass.: Harvard University Press, 1998.

7. For the notion of the "critical" and "clinical" see Gilles Deleuze, "Literature and Life", *Essays Critical and Clinical*, Minneapolis: University of Minnesota Press, 1997.

8. This is what the official campaign of the New York Metropolitan Transit Authority "If You See Something Say Something" says to the city's residents:

"If You See Something, Say Something. Call 1-888-NYC SAFE. The vigilance of all New Yorkers has kept MTA buses, subways, and railroads safe. The MTA thanks our passengers and reminds them to: Be alert to unattended packages. Be wary of suspicious behavior. Take notice of people in bulky or inappropriate clothing. Report exposed wiring or other irregularities. Report anyone tampering with surveillance cameras or entering unauthorized areas. Learn the basics of safe train evacuation. And remember, if you see something, say something. Alert a police officer, train or bus operator, station personnel or call 888-NYC-SAFE (888-692-7233)."

See also "MTA Rolls Out 'The Eyes of New York' Ad Campaign", www.mta.info/mta/news/newsroom/eyesecurity.htm, "MTA Announces A State of the Art Integrated Electronic Security System for NY Transportation Network" and "'Good Call' Builds on Successful Security Campaign Security Communications", both in www.mta.info.

9. The Patriot Act is an Act of Congress which President George W Bush signed into law on October 26, 2001, 45 days after the September 11 attacks. The Act was passed on the World Trade Center Site in New York City. Its full name is "Uniting and Strengthening America by Providing Appropriate Tools Required to Intercept and Obstruct Terrorism Act of 2001."

10. Translation from Susan Buck-Morss, *Hegel, Haiti and Universal History*, Pittsburgh: Pittsburgh University Press, 2009. Original in Karl Rosenkranz, *Georg Wilhelm Friedrich Hegels Leben*, Berlin: Dubcker abd Humblot, 1844, p. 543.

11. For an elaboration of *parrhesia* see Michel Foucault, "The World Parrhesia" and "The Practice of Parrhesia", *Fearless Speech*, Los Angeles, California: Semiotext[e], 2001.

12. For a discussion of Emmanuel Levinas' concepts of "The Saying", "The Said" and "The Justified Said" see Simon Chritchley, "Levinasian Politics of Ethical Difference" and "Conclusion: Philosophy, Politics and Democracy", *The Ethics of Deconstruction*.

13. On the concepts of tradition of the "vanquished" and history of the "victors" see Stefan Moses, "Benjamin's Politico-theological Model of History", in *History and Memory*. For an elaboration on Walter Benjamin's philosophy of history, see Lucero-Montano Alfredo, "On Walter Benjamin's Concept of History", in http://philosophos.com/philosophy_article_69.html.

14. For the concepts of "critical history" and "monumental history", see Friedrich Nietzsche, *On the Advantage and Disadvantage of History for Life*, Peter Preuss trans., Indianapolis: Hackett Publishing, 1994.

15. For presentation of treatment of post-traumatic stress and role of "post-traumatic testimonies" see Judith Herman, "Remembrance and Mourning" and "Reconnection", *Trauma and Recovery*, New York: Basic Books, 1992.

16. For the concept of *"espace vide"* see Claude Lefort, "On Modern Democracy", *Democracy and Political Theory*, Minneapolis: University of Minnesota Press, 1981.

17. Levinas, "Cities of Refuge".

18. Emile Durkheim differentiated between "repressive" and "restitutive" justice saying that "repressive" law of the past reflected the religious traditions of smaller-scale "mechanical societies", where any infraction of law, however small, was severely punished. By contrast, today's modern, large "organic societies" should allow for "restitution" when legal norms are broken.

19. Levinas, "Cities of Refuge".

20. A *maquiladora* or *maquila* is a factory that imports materials and equipment on a duty-free, tariff-free and cheap labor basis for assembly or manufacturing and then reexports the assembled product, usually back to the originating country.

21. For a discussion of Hannah Arendt's notion of "right to rights" see Bridget L Cotter, "Hannah Arendt and the 'right to have rights', *Hannah Arendt and International Relations: Readings Across the Lines*, Anthony F Lang and John Williams eds, Palgrave Macmillan, 2005. Also in: Claude Leford, *Democracy and Political Theory*, Minneapolis: University of Minnesota, Press, 1988.

22. For Bertolt Brecht's call for "invention" instead of "renovation" see "The Modern Theater is Epic Theater", *Brecht on Theater: The Development of an Aesthetic*, John Willet ed., New York: Hill and Wang, 1964.

23. For the original concept of "organic intellectual" and the "long march through the institutions" (the potential role of intellectuals as agents in countering hegemony) see Antonio Gramsci, "The Intellectuals", *Selections from the Prison Notebooks*, Q Hoare and GN Smith eds/trans, New York: International Publishers, 1971.

24. Moses, "Benjamin's Politico-theological Model of History".

25. See Loïc Wacquant, "Pierre Bourdieu", in *Key Contemporary Thinkers*, London and New York: Macmillan, 2006. According to Loïc Wacquant: "Bourdieu argues that the intellectual is a 'paradoxical, bi-dimensional, being' composed by the unstable but necessary coupling of autonomy and engagement... autonomy of science and the engagement of the scientist are not antithetical but complementary; the former is the necessary condition for the latter. It is because she has gained recognition in the struggles of the scientific or artistic field that the intellectual can claim and exercise the right to intervene in the public sphere on matters for which she has compétency. What is more, to attain its maximum efficacy, such contribution must take a collective form: for scientific autonomy cannot be secured except by the joint mobilization of all scientists against the intrusion of external powers."

26. For an elaboration on the decline of intellectual dissent in academia see also Russel Jacoby, "The New Left on Campus: Long March Through the Institutions", *The Last Intellectuals: American Culture in the Age of Academe*, New York: Basic Books, 1987.

27. For full text of "On the Poverty of Student Life", 1966, see Ken Knabb ed., *Situationist International Anthology*, Berkeley, Calif: Bureau of Public Secrets, 1989.

28. For the context of the use of terms "potentia" and "multitude" see Michael Hardt and Toni Negri, *Empire*, Cambridge, Massachusetts: Harvard University Press, 2000, and Paulo Virno, *A Grammar of the Multitude*, Cambridge, Mass./London: Semiotext[e], 2004.

For the concept of "revolt" (versus "revolution") see Julia Kristeva, *Revolt, She Said*, Brian O'Keeffe trans., Los Angeles, Calif: Semiotext[e], 2002.

For a discussion of Socratic democracy (in opposition to one based on "civic discipline and responsibility") see Dana Villa, *Socratic Citizenship*, Princeton, NJ: Princeton University Press, 2001.

For the concept of "nomadology" and the nomads' "war machine" versus the "state apparatus" see Gilles Deleuze and Félix Guattari, *Nomadology: The War Machine*, New York: Semiotext[e], 2001.

For the concept of "the political" (versus "politics") see Chantal Mouffe, "Democracy, Power and the Political", *The Democratic Paradox*, and *On The Political*, London/New York: Verso 2006.

29. For Jacques Rancière's approach to the process of "emancipation" see *The Ignorant Schoolmaster: Five Lessons in Intellectual Emancipation*, Kristin Ross trans., Stanford: Stanford University Press, 1991.

30. For the call for new artistic methodologies and the importance of 'coalitions' see Critical Art Ensemble, "Observations on Collective Cultural Action", *Variant* 15, Summer 2002.

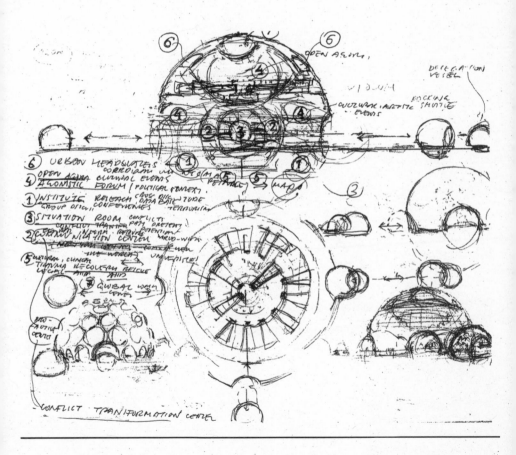

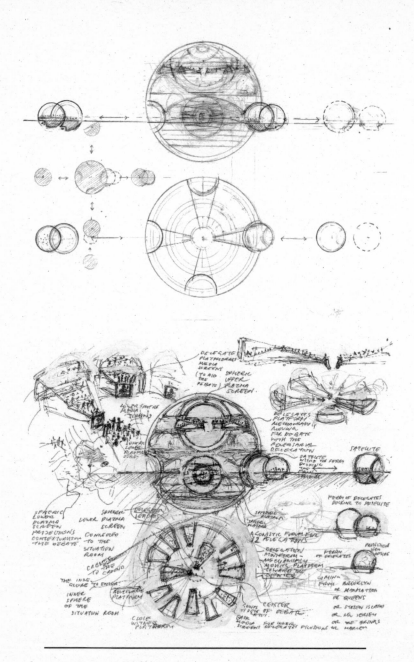

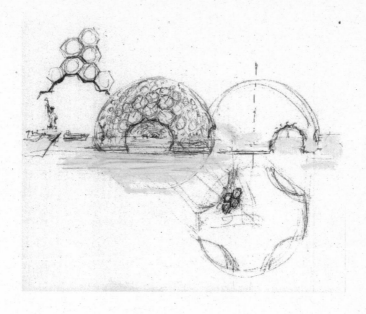

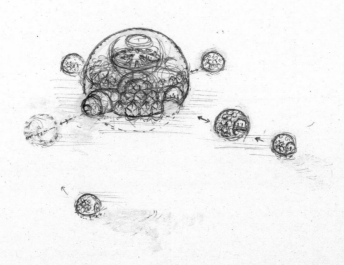

RESPONSES

MECHTILD WIDRICH

MEMORY IN ACTION

At first sight, Krzysztof Wodiczko's proposal seems to occupy a trajectory reaching from French revolutionary architecture of the late eighteenth century to the inhabitable capsules of the *Twelve Ideal Cities*, 1972, by the Florentine architects Superstudio, or the attachable modules of the British group Archigram around the same time. In short, we are in the domain of cosmopolitan avant-garde urbanism. Despite this proximity to utopian iconography, Wodiczko insists that he does want to see the project materialize in quite a modest fashion: "Its utopia is based on the assumption that its effective operation will make it obsolete." The key words "effective operation" recall another architectural tradition. The memorial must *function* in order to reach its goal. What exactly would this effective operation be? Does it necessarily imply construction of the spherical structure with its satellites, including the forum with movable platforms that could literally keep discussants apart if need be, and the 'situation room' at its heart that monitors conflicts worldwide? Or does the detailed account of the various functions of the memorial, in concert with Wodiczko's analysis of the post-September 11 political life of the US, entail a moral act in itself? To pursue this line of thinking, is the publication of this book already part of the strategy for pursuing an agonistic public sphere of critical debate? Does the text itself aim at "effective operation" on its readers?

The suggestion has some historical resonance: philosophies of action have often emerged

from historical catastrophe. Before British philosopher JL Austin proposed his theory of speech acts in the 1950s, he decoded German messages for British intelligence in the Second World War. It was this first-hand war experience of the force of words that made him interested in the circumstances in which the spoken or written word constitutes an action in real life. In order to clarify his concept, he began with a clear distinction of performative from descriptive language: on one hand, there were speech acts effective as social actions, such as the baptism of a ship; on the other hand, there was descriptive language, such as a lecture or a written article, which could be (more or less) true or false. Later in his analysis, he acknowledged the difficulty in distinguishing the two, arguing that speech usually encompassed both descriptive and performative functions.[1] A speech act describes the world it is meant to change, while the most objective argument aims at *changing* something in the world, be it only scientific opinion. That is to say, language (written or spoken), even if it only describes a project in the planning stage—as does Wodiczko's text in this book—aims at changing social realities.

Wodiczko argues for a "memory in action" which ought to work to "transform" the present world. His proposal stands exactly at the intersection of descriptive text and performative action. The format of the book underlines the partaking in this "memory in action": the proposal is not presented in a traditional format, focusing on sketches and

their explanation by the single architect. Before the reader gets to any concrete plan, Wodiczko presents his public with a theoretical analysis of the effects of September 11 and a proposed strategy for social action; more unusually, he opens a discussion about his ideas. Some of the replies are quite critical, which suggests that Wodiczko succeeded in creating the sought-after agonistic public sphere in his own book. In doing so, Wodiczko *shows* how determined he is to open up the project to a performative involvement with this critical audience, and by implication, with a future audience of readers. But the first, in some ways the *ideal*, audience comprises the respondents, who bring their own context and interests in political action to the table, voicing doubts about the operability of the proposal and especially Wodiczko's insistence on the "half-guilt" of all New Yorkers.

Of course this insistence on guilt is provocative. It connects Wodiczko's text to a famous book which—as a call for introspective action—undertook an analysis of humanity's status after the Holocaust: *The Question of German Guilt* published by German philosopher Karl Jaspers in 1946. Jaspers carefully distinguished criminal, political, moral, and metaphysical guilt—all of which he attributed in differing degrees to German citizens—and argued for individual responsibility beyond the legal proceedings addressing the criminal guilt of active participation in National Socialist atrocities. Jaspers raised the issue of personal

responsibility even for those who had 'only' remained silent, or who were not active in their resistance; he agitated against the feeling then common among Germans of being the victims of a lost war. Without acceptance of responsibility for the consequences of political authority, democracy—with the individual as its political unit—would not be able to take hold among the Germans, Jaspers argued. Is it possible to approach history through such individualized moral categories? And while the validity of Jaspers' claim in his historical moment is hardly disputable today, is it not out of line to operate with a similar concept of guilt for the population of New York in the case of September 11—even if Wodiczko's model of "half-guilt" rests on the unconscious or unintentional nature of this guilt? The point of Jaspers' hair-splitting about types and degrees of guilt was not to pass judgment indiscriminately, but to open up processes of reflection and moral-political reformation among German citizens who had convinced themselves—in part due to genuine hardships—that they were passive victims and not citizens from whom responsibility is expected. Wodiczko's analogous call to acknowledge a certain amount of guilt might lead to confusion or rejection among the recipients of the memorial project, but what if we embed it in his broader aim of involving the citizenry in the process of mourning? Wodiczko wants to move his audience to take responsibility for *future* political decisions. The concept of "half-guilt", however questionable from another perspective, is a key element in

turning the description of a traumatized society into a performative call to action, even if the desired action is (political) reflection.

Seen in this light, the detailed functions predicated of the interior of the memorial capsule also make perfect sense. Wodiczko is proposing an information center, a forum for public debates, and facilities to study both the terrorism that occurred and the zones potentially "becoming a fertile ground for the growth and dissemination of terrorist ideologies and actions". The memorial almost resembles an ideal city as mirror of the ideal soul of the citizen, an ambition with a long lineage from Plato to Le Corbusier.

Indeed, the attempt to instill public responsibility for a traumatic past through individual acts of taking responsibility is far from utopian. Decades after Jaspers' uncompromising book, Jürgen Habermas self-consciously took up his call in a more secularized form in his essay "Concerning the Public Use of History", published in a German newspaper in 1986.[2] Habermas extended the responsibility for the Holocaust to the next generation of Germans, most of whom were not born at the time Hitler was in power. Habermas argued that this generation should acknowledge "co-responsibility" for German history. How did Habermas make his case for involving this apparently innocent generation? He argued that all citizens are embedded in a "historical milieu", i.e. that contemporary societies are always built on the

actions, traditions, innovations, and cultural developments of the past. In this sense, all of the past needs to be accounted for, not just the glorious part. As every individual takes part in this historical milieu and profits from it to some extent, Habermas claimed that every citizen needed to take on co-responsibility for the political actions of that society—no matter how distant, unsympathetic, or seemingly immutable they might be. Maybe we need to consider Wodiczko's idea of "half-guilt" in the sense of co-responsibility for the current milieu—after all, we all profit from living in society—in order to understand his call more precisely. In this sense, we could even extend this responsibility far beyond New York, or the US, as Wodiczko suggests at various points in his analysis.

The link I have tried to draw between Wodiczko's proposal and action lies in the concept of the performative: what one does by saying something. This binding force of free speech is a central category for understanding this notion of "memory in action". Wodiczko makes a complicated performative statement: by publicly talking about his project, publishing it as a text in this book, and exposing himself to a critique via the responses, he takes a first step towards an act of commemoration with political consequences in the present (and for the future). This book is thus only in part an attempt to materialize the memorial by making it public. Already at this point, and regardless of whether the project ever gets built, the book itself is "memory in action": a performative

act of commemoration, a discursive platform, yet in itself a memorial or at least one of its "programmatic components".

1. Austin, JL, *How to do Things with Words*, Cambridge, Mass.: Harvard University Press, 1962, and "Performative-Constative", Geoffrey Warnock trans., *Philosophy and Ordinary Language*, Charles E Caton ed., Urbana: University of Illinois Press, 1963.

2. Habermas, Jürgen, "*Vom öffentlichen Gebrauch der Historie*", *Die Zeit*, November 7, 1986. Published in English as "Concerning the Public Use of History", *New German Critique* no. 44, Spring–Summer 1988.

KIRK SAVAGE

THE IMPOSSIBLE MONUMENT

We may always know what is right: but not always what is possible.

John Ruskin, *Seven Lamps of Architecture*[1]

Wodiczko's proposed memorial for September 11 is, on its face, utterly impossible. How could it ever pass muster with the local authorities? Not to mention the families of those who perished in the towers? To begin with, the program has none of the basic elements already deemed essential to the World Trade Center Memorial and museum. No list of names of the dead. No relics from the site. No representation of the tragic events of that day. And no sacred ground: the memorial would float in the water of New York's harbor. Wodiczko's is not a memorial to September 11, but a memorial for September 11—a visionary blueprint for a new kind of aftermath, an urban refuge and an empty slate to be filled with discussion, contention, and action.

Wodiczko's proposal, Ruskin might have said, dramatizes the intellectual gap between what is possible and what is right. Focusing on the possible, Ruskin once argued, clouds our judgment of the right; to surrender to the merely possible is to accept the mental limitations and hypocrisies of our own time. The pursuit of what is right, on the other hand, may expose us to ridicule and failure. Even so "it is a more dangerous error to permit the consideration of means to interfere with our conception."[2]

And yet, is Wodiczko's proposal nothing more than a utopian 'conception', an intellectual

exercise? He is interested not just in a thought experiment but in action. His own "Afterword" challenges us to act in the world. It is therefore understandable, even legitimate, to ask what concrete action his impossible conception could possibly inspire.

Wodiczko's memorial has as little in common with the standard memorial design of today as Boullée's 1784 proposed cenotaph to Newton had with the typical hero monuments of the eighteenth century. Boullée had no interest in the traditional effigy of the hero, with its attendant edifying inscriptions. Instead, like Wodiczko, he envisioned an immense hollow sphere. Perforated with holes for stars, Boullée's was a veritable universe that was less about Newton and more about the nation's citizenry and their own quest for harmony.[3] Wodiczko's design is a literal public sphere, a microcosm not of a harmonious social universe but of the agonistic one he hopes his City of Refuge can become.

In the past century the hero monument has withered, and the victim monument has flourished. The old-fashioned celebration of triumph has increasingly given way to the therapeutic process of recovery.[4] If the traditional monument trumpeted our ever-expanding collective being, or, more modestly, our triumph over outside threat, the therapeutic memorial assembles the traumatized remnants of our being and tries to make them whole again. In the process the two existential categories—hero and victim—have

become muddled, slipping from one to the other. Hence the sacrificial American dead of the Vietnam War slip into victimhood on Maya Lin's wall, and the unconsenting victims of al Qaida's attacks become 'heroes' on the official viewing fence at Ground Zero.

Lin's radically compressed solution, which makes the names of the dead the beginning and end of the memorial, has become the gold standard of memorial design. It is a reconciling space, not an agonistic one, deliberately clearing away all the moral and political debates over the war's purpose and forcing us instead to confront the simple fact of the soldiers' deaths. Lin did not imagine a collective discussion but a private reckoning between spectator and wall.[5] Her memorial asks us to honor these names and to reckon with their deaths, but it does not ask us to question the standard political calculus by which their names and not others' are chosen to be chiseled in stone, on this collective ground. While the memorial has helped veterans and their families work through the war's trauma, it has not produced a collective reconsideration of the war's many other victims, or of our culpability toward them, or even of the war's failure to meet its stated goals. Astonishingly, a mere two decades after the memorial opened, the US government drove its military into the quagmires of Afghanistan and Iraq, exacting a terrible toll once again on civilian noncombatants, on the same mistaken assumption that the 'shock and awe' of overwhelmingly destructive firepower

could somehow 'build' compliant nations and pacify their rebellious populations.

Wodiczko's memorial for September 11 abandons the rhetoric of honor and healing alike. We are not to be allowed such comfort, either by saluting the dead or by sharing the survivors' pain. His program makes no attempt to explain the event or identify its victim-heroes; the whole process of inscription is forsaken. He wants no names that cry out to be avenged, or even to be recognized. Because whose names should be recognized, and why? In his scheme that is a question to be put up for discussion, not to be resolved in stone. The list of possible victims or survivors of September 11, according to Wodiczko, might expand to include traumatized US soldiers and their families, Afghan and Iraqi soldiers and civilians, domestic victims of Homeland Security repression. The memorial could be conceived, in part, as a site to collect these adversarial testimonies, to redefine the parameters of the event and debate its significance, and to take new action in response.

Agonistic discussion, as Wodiczko envisions it, threatens the very mission of the therapeutic memorial. The process of recovery demands clarity. The victim must be acknowledged and must be declared innocent: there can be no blaming, no suggestion that the victim 'asked for it'. Wodiczko's insistence that the memorial space should acknowledge our own half-guilt and half-innocence would seem to undermine the necessary 'moral clarity' and would perhaps even excuse the perpetrators.

Of course Wodiczko has a response: "The fact that so many among us became victims and remain traumatized survivors does not mean that we should not learn a political and ethical lesson from our losses for the future." We can insist on the absolute blamelessness of the victims in their own suffering and death, and at the same time examine our own (unknowing, half-knowing) complicity in the global conditions that make acts of violence commonplace. Just as we can insist on the rape victim's innocence at the hand of the perpetrator and still consider our own investment in the asymmetrical power relations that make women's bodies so vulnerable. Though we are right to absolve individuals for the crimes committed against them, we can hold ourselves responsible for the collective actions (or inactions) that create the breeding ground for such crimes. But to do one and the other simultaneously means that we complicate the issue of recovery and move into a different ethical register; now we look in the mirror and take responsibility for the collective perpetration of injustice we unknowingly or half-knowingly support.

We can do this, Wodiczko suggests, only in a City of Refuge where we are protected from acts of vengeance from outside and relieved of the burden of enacting vengeance ourselves. Here victims, survivors, accusers, bystanders all come together as half-innocent, half-guilty, not to excuse their own or others' crimes, but to demand an accounting and to take action to alleviate the injustices that make this accounting necessary.

Do we even need or want a memorial for September 11? It could be argued that in this era any memorial of a terrorist action only advances the agenda of the terrorists. They feed on spectacle and publicity: the longer and deeper the impact of the event, the better for them. Al Qaida had four planes and a couple of hours to create a catastrophe it hoped would be remembered forever; memorials to the disaster fulfill that dream. Not all perpetrators, of course, would welcome a monument to their crimes. The Nazis had an entire industrial apparatus of death spread across central Europe working 24 hours a day for years, but they did not publicize it. The Holocaust memorial in Washington therefore compels us to *verify* what happened, to bring its victims back from oblivion into the historical record.

But in either case, that of September 11 or the Holocaust, the only reasonable rationale for returning to the disaster is to keep our attention focused so that we work to prevent similar atrocities from ever happening again. What good is 'recovery' if we learn nothing or do nothing? Wodiczko emphasizes that, etymologically, memorials are meant to mind and remind, to warn for the future even more than to rehearse the past. Memorials fail unless they connect the historical event to the present and the future, and thereby create a platform for action. But since most memorials are bound to inscribe the past in a fixed container, to make authoritative statements about the nature and significance of the historical event ("here is what took place,

here are the dead numbered and identified"), they seal themselves off from the processes of debate and revision and curtail the possibilities for active response. Instead of asking "what happened?" Wodiczko's memorial asks "what is happening now?" His intent is to make the very processes of re-thinking and response, reminding and re-action, the subject of his memorial. The 2,800 dead at the World Trade Center become connected to events before and after, to other tragedies and other injustices across the globe, which solicit not just our righteous indignation but a real reckoning of our own half-guilt, half-innocence, and concrete action in response to today's dilemmas.

Which brings me back to my original question: can Wodiczko's proposal do anything more than remind us how inadequate, and even counterproductive, our disaster memorials are? Can his idea actually change how we approach the task of commemoration? Agonistic discussion and self-critical thought are clearly not for everyone, and hardly consistent with a business-model approach to historical sites— note that Wodiczko does not plan his memorial for tourists but for New Yorkers, those who come to live in the City of Refuge. Nonetheless his proposal does address some of the same concerns that professional museum and memorial designers have. They tend to share his desire to change consciousness and produce positive action. They worry about how to keep their sites current as the memorialized event slips further into history. They realize that true 'interactivity' must go beyond pushing

buttons or touching a computer screen. Yet the boundary lines of their professions, and the limitations of our own models of commemoration, work against them.

Is it possible that the traditional aura of the monument (the site, the relic, the names) could be used not just to attract visitors but to spur them to think, speak, and act? This is hardly Wodiczko's concern, since he rejects such 'parareligious' icons altogether. And indeed a monument built around such a sacred core would have to work against its own tendency to become an oracle, an unquestioned voice of authority that demands deference and silences its visitors.[6] For a monument to September 11 this is especially problematic: the names of the dead silenced by al-Qaida could be used in turn to silence us, as if any attempt to speak and debate in their presence was blasphemy. If the dead themselves could speak, though, their voices would no doubt have many different perspectives, as they came from dozens of nations across the globe, some of them illegally. Could a therapeutic memorial or documentary museum use these spectral voices to create an anti-oracular monument, a space open to a multiplicity of viewpoints shaped in other parts of the world and by other events in the past and future? This is not Wodiczko's question but one that his own stance might prod us to ask when confronted with the pragmatic problem of what to do at Ground Zero.

Perhaps the right question is not whether Wodiczko's 'conception' is at all possible. Most of us did not think the events of September 11 were possible; humility would suggest that we cannot predict what is possible in their aftermath. Perhaps the better question is whether it is possible to escape the challenge he has set for us.

1. Ruskin, John, *Seven Lamps of Architecture*, 2nd edition, New York: Dover, 1989, reprint of 1880, p. 2.

2. Ruskin, *Seven Lamps of Architecture*, p. 1.

3. Rosenau, Helen, *Boullée & Visionary Architecture*, London: Academy Editions, 1976, p. 107.

4. For an admittedly preliminary history of this shift, and additional remarks on its significance, see my *Monument Wars: Washington D.C., the National Mall, and the Transformation of the Memorial Landscape*, Berkeley: University of California Press, 2009, pp. 236–244, 266–295.

5. Savage, Kirk, *Monument Wars*, pp. 270–271.

6. For the notion of monument as oracle I am indebted to discussions with Fred Evans and to his book *The Multivoiced Body: Society and Communication in the Age of Diversity*, New York: Columbia University Press, 2009, esp. pp. 11, 207–211.

MARK JARZOMBEK

THE CIVILIAN AND THE CRISIS OF THE UTOPIAN MONUMENT

I would like to raise two questions regarding Krzysztof Wodiczko's City of Refuge. Who are the inhabitants of this city, and what is the theoretical status of that population? I will try to address these questions by pointing to what I believe is a subtext of Wodiczko's urban vision—the distinction between a 'citizen' and a 'civilian'.[1]

The word "civilian" underwent several revisions in the past centuries. In its original meaning it referred to the lawyers who specialized in civil law. During the English colonialization of India, it came to refer to the English-born administrative personnel and their families. In the nineteenth century, with the development of the armed forces into self-contained military entities, the word was expanded to embrace non-military people in a more general sense.[2] Following the Second World War, the word became a type of cultural imaginary. Civilians were seen as society's constitutive fabric, existing ideally in a natural state of peacefulness. This redefinition was a consequence of the Fourth Geneva Convention, 1949–1950, whose aim was to set forth protocols that could save lives during times of war. The implicit hypothesis was that after hostilities had ceased, civilians were to be the essential component of a return to normalcy.[3] Military conflict represented disruption, whereas the civilian world represented continuity.

The new concept of a 'civilian' challenges the traditional concept of the 'citizen' that arose

during the Napoleonic era when citizenship, nationalism, and warfare came to be fused into a potent mix. A citizen in that sense was more than just a legal personage with voting privileges; it was assumed that he possessed a positive relationship to the state. Since he had to be willing to die for his country, he was accorded a different type of death than his predecessor. Tombstones were no longer decorated with skull and bones—indicating the immanent and perhaps not all too pleasant reckoning—but with smiling angels and historical references to Egypt, and set in tranquil wooded parks. Even though the industrialization of war and the advancements in chemistry made the slaughter of humans all the easier, the basic equation of citizenship, heroism and death—and, of course, the monument as a site of positive national reflection—remained intact. It is still, globally, the dominant component of national politics.

Nonetheless, the post-Second World War conceptualization of the 'civilian' introduced a new term into global political equations. Whereas the 'citizen' is by definition guilty by association, the 'civilian' is assumed to be disengaged from a body politic and perhaps even a victim of it. The line between a civilian and a refugee is all too thin. In this scenario, the civilian is not only a non-combatant but a non-citizen as well. The Convention insists that people in internment camps receive regular mail, get care packages, and be given adequate clothing. But nowhere does it say that they have any political or representational rights. There is one world of perpetrators, another of innocents, and a third of United Nations observers. Because of the negative images associated with refugees, the post-Second World War definition of 'civilian' does not threaten the embedded structures of citizenship. It brings to mind images of crowds of people clogging bridges, abandoned children crying on the roadside, and the elderly hugging blankets and huddling in hastily erected tents. In short, what we often see is humanity torn from its moorings. Such images make it difficult to extend the principle of the 'civilian' into a utopian project, for—unlike citizens who are assumed to be fully enabled members of society carrying guns and legally entrusted with the task of killing the enemy—the civilian is projected into the role of an apolitical entity with no implicit powers except perhaps survival.

Krzysztof Wodiczko's City of Refuge asks us, so I argue, to go past this negative image. The city is not merely protected from the structured arbitrariness of violence—any Red Cross shelter can do that—but is a locality where a new type of urban civility can take root. People will talk to each other not as members of the UN, not as ambassadors speaking ostensibly for the rights of their constituents, not as 'protectors' of the innocent, not as desperate refugees, and especially not as 'citizens', but as individuals addressing each other in the context of agonistically-framed discussions that aim to optimize the opportunity for people to express their disagreement.

There is a hidden complexity in this urban encounter that needs to be factored into the discussion. It stems from the fact that civilians—despite the attempt to construe them as innocents—are not neutral entities. The Convention seems to address this issue by acknowledging the potential presence of spies and saboteurs. "Such persons shall, in those cases where absolute military security so requires, be regarded as having forfeited rights of communication under the present Convention."[4] This is the least of the problems with the designation 'civilian'.

Along with the leftovers of their lives—the Convention allows all refugees to have 25 kilograms of baggage—civilians carry with them the concealed weight of psychological trauma.[5] Initially, in the 1980s, it was thought that trauma affected only the combatants. And indeed, most of the early post-Vietnam research into the impact of war on the human psyche focused on men in uniform. But recently, there has been a growing amount of research with respect to the traumatic impact of war episodes on the civilian population. These studies were so belated in the history of psychoanalysis—given that terror is so *obviously* embedded in modern life—that one researcher has accused psychoanalysis of having had a type of 'amnesia' in dealing with the phenomenon.[6] He pointed out that it took three horrific wars—the First World War, the Second World War and the Vietnam War—and numerous holocausts, mass murders, forced migrations, and civilian

transgressions, before the psychological impact of terror on civilian populations was recognized by the scientific community.[7] In fact, even when post-traumatic stress disorder (PTSD) was first defined in the early 1980s, it was still thought to be something "outside the range of usual human experience", reserved for war veterans or sexual abuse victims. In other words, if we think of the millennia of human aggression, it is only in the last ten years or so that 'the civilian' has come to be seen as psychologically as well as physically abused! Even the Geneva Convention, which took place before the era of PTSD, makes no mention of people's psychological needs. The reason for the amnesia had a lot to do with the fact that non-combatants were not expected to be traumatized. Women and children—as 'innocents' and as thus conceptually removed from the guilt of war—could not possibly be psychologically burdened by the events around them. That was reserved for those who put their lives on the line. Today we see the world differently. In fact, PTSD is now ranked along with cancer and heart disease as the third most serious and debilitating problem in the US.[8] A recent article in *The Boston Globe*, entitled "Battling a Different Kind of War", discussed decommissioned soldiers (and thus civilians) who bring their emotional battles into the domestic sphere.[9] The family unit has become a sleeper cell disguising and magnifying traumatic memory. This means that the 'civilian' has expanded from being the site of post-military, social stability—as the utopian subtext of

civilizational resiliency—into an ambiguous project of social contamination, creating a new class of people composed of citizens/civilians who live with the threat that—though 'non-combatants'—they could easily become combatants of a sort, fighting not men and machines, but the elusive ghosts that accompany the shockwaves of history. Thus the term "civilian" contains in its meaning, on the one hand, a society presumed to be in a natural state of peacefulness, and, on the other hand, a society that is irrevocably at the mercy of the brutal aftereffects of modern warfare. Unlike the citizen who lives at peace or at war, the civilian is a negative dialectical construction, a non-combatant irrevocably tied to the realities of combat. The civilian is sucked into the core traumas of our shared history, inflecting and infecting citizenship itself. And at any moment, the civilian in this equation can bring into the open what the citizen by definition must deny: the gruesome legacy of war.

The result is a sociopolitical territory with its own economy of production and its own politics of identification, in other words, its own culture, redefining the everyday ebb and flow of life, death and memory. But whereas the citizen is represented on the world stage by the UN, the civilian—apart from the remote and simplistic ambitions of the Fourth Geneva Convention—has no representation. Whereas the first is honored by monuments that identify the centrality of patriotic sacrifice, the latter has nothing, except where slaughtered by

thousands or millions; civilians get recognition only if their murder figures into a nationalist purpose, in other words where the history of their events can be exploited to quicken the pulse of citizenship. Some societies have acknowledged their guilt and complicity in the death and traumatization of civilians, but others have not done so and never will. The reason is the tendency to prefer a radical reduction of meaning and to see terror through the language of aggressor and victim, of action and repair, and of evil and good. But if we look to the further reaches of brutality's shockwave, we encounter a different and more diffuse cultural landscape where violence is more insidious, where 'civilianness' and its surging traumatic impulses appear and disappear underneath the enforced civilizational certainties of citizenship.

Krzysztof Wodiczko's City of Refuge—in the form of a giant sphere floating in the Hudson River—addresses this cultural transformation. In that sense, it looks not so much to the past—to the shock of 9/11—but to a future. It is not a floating artwork or a counterculture community of fellowship and love, but a place where one leaves the romance and the hardened and failed world of citizenship for the ambiguous and novel world filled with ghost-like uncertainties. One could contrast this sphere with the giant golden sphere of Auroville, India, in which one is expected to meditate and seek personal tranquility. Auroville was founded in 1968 with the support of UNESCO in order "to realize human unity—

in diversity".[10] According to its promotional brochure it is a place where "men and women of all countries are able to live in peace and progressive harmony above all creeds, all politics and all nationalities".[11] The Auroville sphere is designed to assist individuals in this. It serves as a place where residents can sit and meditate in silence. But this does not remove the 'citizen' from the ontology of its inhabitants. In fact, regardless of the inner humanity that can be perhaps found inside the sphere, outside of it, in the city, individuals are assumed to implicitly 'represent' their country. This activity is magnified by the fact that there are no urban institutions in the conventional sense. Anyone can build any kind of house he wants, anywhere.

The City of Refuge asks for something more difficult, namely that citizenship be removed long enough to expose not the much longed-for universal subject of 'humanity', but a world in which the impossibility of pure civilianship is acknowledged and expressed. It critiques both the ideology of the citizen and the ideology of the pure civilian. In the process it acknowledges that civilians will bring with them their various traumas and combats. Instead of suppressing institutions, as in Auroville, trauma in the City of Refuge is tempered by a range of institutions, a 'situation room', an agora, and a broadcast center—placed on top of each other in the sphere and held together by facilities for historical, philosophical and cross-disciplinary study of the conditions and forms of terrorism

and terror. The globe is fully modern (verging on the postmodern), accepting the interplay of combatant and non-combatant realities as well as free and processed speech.

The City of Refuge is not accusatory in the traditional, avant-gardist sense. Its 'apoliticalness' could strike one, in fact, as all too passive. But seen through the lens of the citizen/civilian dialectic, the city pulses with productive impossibility. Its inhabitants constitute a conundrum. On the one hand, they embody a mode of freedom. On the other hand, they have survived where others did not. The city is not a place of 'healing' but rather a place that challenges forth—despite its idealism—the telling, recording and broadcasting of tragedy. It forces the dual genealogies of trauma and history into the open. Trauma, which had been set adrift into the common culture by the instruments of the state—by its citizens/combatants—is brought back to its finitude by non-citizens/civilians (combatants) in the moment at which its limits seem to disappear. For this to work itself out, it needs its own place—its own utopia.

1. See also Mark Jarzombek, "The Post-Traumatic Turn and the Art of Walid Ra'ad and Krzysztof Wodiczko: From Theory to Trope and Beyond", *Trauma and Visuality in Modernity*, Lisa Saltzman and Eric Rosenberg eds, Lebanon: Dartmouth College Press/University Press of New England, 2006, pp. 249–260.

2. For a discussion of the emergence of the modern war see David A Bell, *The First Total War,*

Napoleon's Europe and the Birth of Warfare as We Know It, Boston: Houghton Mifflin Co., 2007. In the 1830s, the term "civilian" had become, as the famous English author Thomas De Quincey put it, "fashionable". See for example, Thomas De Quincey, "Richard Bentley", *The Works of Thomas De Quincey*, Edinburgh: Adam and Charles Black, 1863.

3. This should not be confused with the better-known Third Geneva Convention, which deals with the treatment of prisoners of war.

4. Part I, Article 5, the Fourth Geneva Convention, August 12, 1949.

5. Chapter X, Article 128.

6. See Bessel A van der Kolk, Lars Weisæth, and Onno van der Hart, "History of Trauma in Psychiatry", in *Traumatic Stress*, Bessel A van Kolk, Alexander C McFarlane, and Lars Weisaeth eds, New York: Guilford Press, 1996, p. 67.

7. Even when the need to come to terms with civilian trauma was recognized, the scientific community still proceeded cautiously. American Psychiatric Association, *Diagnostic and Statistical Manual of Psychiatric Disorders*, vol. 3 (DSM-III), Washington, DC: American Psychiatric Association, 1980, p. 236. This manual is one of the earliest attempts to codify the diagnostic criteria of post-traumatic stress disorder. An important book regarding Vietnam veterans is *Post-Traumatic Stress Disorder: A Handbook for Clinicians*, Tom Williams ed., Cincinnati: Disabled American Veterans, 1987.

8. According to Ronald Kessler, a Professor of Health Care Policy at Harvard Medical School, research in the US suggests that 38 percent of people with PTSD are in treatment in a given year. The majority of these patients (28 percent of cases and 75 percent of those in treatment) are cared for in the medical sector of the treatment system, while the rest are in the human services sector (i.e. seen by spiritual counselors or social workers) or the self-help sector. Approximately 22 percent of those with PTSD (58 percent of those in treatment) are in treatment with a psychiatrist, clinical psychologist, or other mental health professional. See Ronald C Kessler, "Post-Traumatic Stress Disorder: The Burden to the Individual and to Society", in www.lawandpsychiatry.com. Furthermore, it is estimated that 20 million adults in the US suffer from depression each year, and up to 25 percent of all women and up to 12 percent of all men in the US experience an episode of major depression at some time in their lives.

9. Peter Schworm, "Battling a Different Kind of War", *The Boston Globe*, Saturday, May 2, 2009.

10. http://www.auroville.org/av_brief.htm, May 2009.

11. http://www.auroville.org, May 2009.

ANDREW M SHANKEN

GUILT ARCHITECTURE

People around the world struggle to fathom the attention Americans have paid to the events of September 11. In nations where terrorism is a daily reality, if not routine, the American response comes across as an overreaction of pathological proportions. Now, as we anticipate the decennial with a memorial of such monumental proportions, we must ponder the pathos packed into that pathology before we can assess the memorial itself.

The attack on the towers laid bare the essential vulnerability of a nation girdled by ocean, isolated by temperament, insulated by wealth, and armored by delusions of the inevitability of its own ideological triumph. For decades, aside from the fear of nuclear annihilation, the continent understood vulnerability in terms of internal violence. The US, in particular, bolstered institutions that policed, incarcerated, and controlled its own population, with catastrophic consequences for race and class, and ultimately, democracy. In recent decades, the most notorious acts of violence committed on "American soil"—a term that draws attention to the exceptionalism born of isolation—were mostly self-inflicted. From gang warfare and race riots to the bombing in Oklahoma City and shootings at Columbine, Americans were far more likely to confront a gangbanger, psychotic mass murderer, or an angry mob than a terrorist. This is still the case, but no one would know it from the way the nation behaves. Where is the amber alert about racial inequality? Where is a Patriot Act aimed at

the intransigent poverty that undermines all economic and moral wellbeing?

The inversion of the American perception of vulnerability on September 11 came with a rude shock. The uncanny register of demographics and morphology in post-war American cities, from the highway system to the malls, subdivisions, ex-urban fringe, and edge cities, arose in part to protect elites from the internal threat. 9/11 revealed the impotence of this elaborate system of defense. More unsettling, the emergent external threat was really an internal one: the enemy lurked in hidden cells that used technology to transcend the spatial order of race and class. In response, the government has since erected an immensely complex system of informational defense—i.e. surveillance, off-shore detention and torture, wiretapping its own citizens, and profiling. In short, we live in a quasi-police state, which offers defense instead of mourning, suspicion in place of understanding, and vengeance in lieu of positive action. All of this intensifies the feeling of vulnerability, channeling the trauma associated with the event into the dwindling possibility of defense, let alone the increasingly meager release of vengeance.

The obsessive urge to memorialize the events of September 11 and to do so in such a grand manner emerge, at least in part, from this pathology. Krzysztof Wodiczko's City of Refuge, possibly the grandest proposal for a memorial to the event, attempts to move beyond trauma to imagine a form of democratic action that would address the entire cultural edifice erected to protect Americans from their vulnerability, a large part of which is their own overblown response to the event. In this sense, the logic is a bit circular, but the effort is so remarkable, so intricate in its attempt to fathom the complexity of response, that it balances out the banality of efforts to materialize that cultural edifice in permanent form. To outsiders, it may seem like much ado about nothing, an objectification of the grotesque pathology. And so it is. And so is every great memorial.

Typologically speaking, this is a more conventional memorial than it first appears to be. To conceive of the memorial as a civic institution, an interpretive center, or as a museum goes back at least to the Civil War. The nerve center of the movement for such useful memorials has been a civic-minded brand of American pragmatism mixed with puritan thrift, whose less sympathetic side evinces a kind of biblical antipathy to purely symbolic memorial gestures as graven images or useless indulgences. Columns, arches, and statues suggested the "bogey of popery", as the insightful Protestant Philip Johnson put it during the Second World War, when the movement hit its apogee.[1] The lurking implication is that these traditional forms were inert, incapable of rousing people to action—a core concern for the philosophical heroes of pragmatism, such as Charles Peirce, John Dewey, and William James, who rejected the assumed split between knowledge and action in human experience. Memorials that aimed to foster contemplation

through an eternal object—even of such high ideals as liberty, sacrifice, or heroism—stymied true inquiry, understood as the way in which people come to terms with their environment. Thus in modern America memorials have been saddled with an immensely complex duty: to assist people in reconciling themselves to tragedy or loss by prompting them to action. Ergo useful memorials. Can architecture do this? Such a belief was also at the core of the Modern movement, and may be one reason why European ideas about architecture found such fertile ground in the US. To propose the City of Refuge as a 'working space' thus attaches it to deep-seated American attitudes intertwined with a material determinism most stridently expressed in Europe between the wars. Wodiczko seeks an institute that would serve as a forum for "operative memory, memory in action", one that would be an agent of cultural and ideological transformation.

Wodiczko explicitly places pathos at the core of the institution. This is one of the most original parts of the project. Where most memorials assume the conventional emotions of mourning, City of Refuge is based on a philosophical interpretation of the nature of guilt. A growing body of literature addresses the mysterious relationship between emotion and space. Thus far, however, emotional geography has had little to say about memorials, which, arguably more than any other part of the built environment, participate in the realms of pathos. Wodiczko's primary source is the Jewish notion of half-guilt and half-innocence. Guilt is understood by the artist in Judeo-Christian terms as a state of culpability. But of course there can be no social concept of guiltiness without making vast use of the emotion of guilt. He uses the construction of "half-guilt" as a spur to move beyond the necessary, but limited, paradigm that treats memorials as devices that help people work through trauma. This is an important step.

Beyond this psychoanalytical lens, he believes, lies the potential for responsibility through ameliorative action in the world. This memorial would be a center of learning that would inspire such action. In fact, the institution is to act as a kind of guilt sifter, since "some of us are half-guilty and half-innocent, but some may be more-than-less guilty—much less than half-innocent". An institution of reckoning, it would allow us "critically and historically [to] analyze and debate every dimension of the half-guilty and half-innocent state evoked and inscribed in our consciences by the horrors of the September 11 attacks and their aftermath". But is guilt really the social construct or the emotion we want to tap? Should responsible action in the world grow from a collective sense of negotiated guilt, or might we make use of other more positive emotions, such as surprise, wonder, hope, or even ambiguous ones, such as pride, envy, or longing? If guilt truly is the base emotion out of which this "memorial work" is to be done, how do we begin to consider an architecture of guilt, or a guilt environment? Great monuments of the past have promised earnestly and fruitlessly

to bring us to higher states of consciousness about our world and ourselves by appealing to emotions. Besides centering emotion and attaching it to a theory of action, what is different about this one?

The City of Refuge places a special responsibility on the memorial-institution, well beyond the usual purview of the living memorial. It burdens it with the responsibility of monitoring violence and terror, and probing deeply enough into the psychosocial folds of the human condition to ferret out "the symptomatic signs of material and psychosocial conditions that foster revanchiste tendencies". The 'memorial', for the increasingly complex concept demands quotes, would be replete with—just to skim the surface of its program—a 'situation room', a multimedia broadcasting station, and an office housing a "legal aid, social work, political advocacy, medical care and human-rescue program"; it will invert the role of the surveillance complex, using it for benign ends.[2] As with the useful memorials that grew up in the mid-twentieth century, the lines that connect memory and other functions become increasingly blurred. No longer a memorial, it is a vast network of institutions created to counterbalance the military-industrial-media complex, its fundamentalist enemies, and the perverse American response to it all.

All of this is to be placed on an artificial island. The metaphor—and reality—of making a memorial island complicates both the emotional basis and the intention to create

an active memorial. The first level of the metaphor is obvious: a mini-Manhattan—its memorial other—would surface out of the New York harbor, melding September 11 into an archipelago of freedom. The urge to create such a metaphorical island follows age-old habits in memorialization of separating the sacred memorial from its profane setting—a separation, incidentally, made ambiguous by the mandate for working or useful memorials. Most traditional memorials have sought a similar isolation through the use of special materials, placement, and calendrical exceptionalism.[3] An island is an odd choice for a place of such dynamic institutional blur. And yet how American! And how New York! At once Tatlinesque and American exceptionalist, it ushers in a new era of visionary memorials. The American pathology has met its match.

1. Johnson, Philip, "War Memorials: What Aesthetic Price Glory?", *Art News* 44, September 1945, p. 9.

2. In addition to wondering whether this is possible, we must also wonder, where will it find its staff? Given its purview, it would have to recruit from Central Intelligence, Mosad, Radio Free Europe, Lawyers without Border, and the Parapsychology Lab at Duke University.

3. In fact, this would not be the first memorial island as such. The USS Arizona Memorial sets up some of the same distinctions, forcing visitors to take a literal and metaphorical journey in order to reach the memorial realm.

LISA SALTZMAN

NON-SITE, UTOPIA, COUNTER-MEMORIAL

Let us envisage it as a structure to be placed not on solid ground but on water, on unstable ground, one connected through the ocean to stormy lands overseas, the lands of troubles in which we may be implicated—the symbolic and historic connection with the world or our unintentional global deeds and a potential point from which the new intentional and unintentional exiles may come.

Krzysztof Wodiczko
A Memorial for September 11

Let us envisage it, this City of Refuge, through the lens of its immediate and more distant histories. As dusk approached on the evening of September 17, 2005, a small crowd of people gathered on the Christopher Street Pier and along the pathways of the Hudson River Park. Couples chatted. Children played. Dogs strained at their leashes. Not long after, there arose an audible collective gasp, followed by a few hoots, cheers and cries of glee. With that, the crowd surged forward, pressing against the rails to catch a better glimpse of the anticipated event. And what did they see? There, in the distance, were a tugboat and a barge, the tethered pair slowly making its way up the Hudson toward the banks of Lower Manhattan. There, coming into ever-sharper focus as it approached the pier, was Robert Smithson's *Floating Island*.

Conceived in 1970 but, despite his efforts, never realized during his truncated lifetime, it was only in 2005, with the work of Smithson's widow, Nancy Holt, and the support of Minetta Brook and the Whitney Museum of Art, that the project saw its way to the waters of New York.

71

From that Saturday, September 17 through the following Sunday, September 25, a 30 x 90 foot barge landscaped with earth, rocks and native trees and shrubs was towed by a small tugboat through the waters around Manhattan, visible from both the Hudson and East River waterfronts. An unmoored, uninhabited island that suggested in its regional flora and rectangular form a miniaturized, displaced Central Park, Smithson's *Floating Island* belatedly instantiated what had for 35 years remained but a sketch, an artistic proposal, an aesthetic possibility.[1]

Committed to paper in the same historical moment as such similarly unrealized 'island' projects as his *Hypothetical Continent of Lemuria*—conceived in Sanibel during a visit to Robert Rauschenberg's Captiva compound off the Gulf Coast of Florida—and *Map of Broken Glass (Atlantis)*—envisioned for the waters of Vancouver—*Floating Island to Travel around Manhattan* shifted their terms of aesthetic and conceptual engagement from the unabashedly hypothetical to the concretely material. Unlike Smithson's plans for those imagined lost continents, geographies long adrift in the cultural imagination, his sketch of *Floating Island to Travel around Manhattan* proposed a fundamentally different sort of landmass, one that might circumnavigate the waters of New York Harbor. Here, Smithson conceived a project that would press the non-site—that aesthetic and conceptual category that had been for him so critical and productive—into the realm of political philosophy, toward that

ideal place, that island, that non-place, that we know also as utopia.

A philosophy of the future with roots in the imagined paradises of antiquity, contemporary utopianism is driven as much by cultural fantasy as by social agency, as much by Thomas More's 1517 *Utopia* and literary or cinematic science fiction as by the writings of Marx, Engels, Bloch and Marcuse.[2] To claim Smithson's category of the non-site as an instance of utopia, or utopian reinvention, is to shift the discussion of Smithson's work squarely into the realm of the political—it is to find in the earthwork something of the ethical.[3] Proposed in a moment when landfill had only just expanded the geography of Lower Manhattan to include Battery Park City, much as earlier urban projects of land expansion and waterway reclamation had created Boston's Back Bay, Smithson's *Floating Island* could be said to have envisioned an alternative model of urban renewal. If Frederick Law Olmsted gave to New Yorkers a public park that might preserve, in the rapidly urbanizing grid of Manhattan, the idea and experience of nature, of landscape, of the picturesque, Smithson put forth again and anew that Jeffersonian, democratic dialectic between the sylvan and the industrial. As such, the 1970 sketch gave graphic if not material form to the ideas that would emerge more fully in Smithson's 1973 *Artforum* article on Olmsted and the dialectical landscape.[4]

As a work on paper, of course, Smithson's drawing might well represent neither utopian

promise nor reinvention, but, instead, yet another iteration of the persistent cultural *topos* that so structured the pictorial imagination of modernity—the island as a site of pleasure, escape, and recreation. We need only think of such works as Antoine Watteau's *Embarkation from the Island of Cythera*, Paul Gauguin's entire Tahitian *oeuvre*, or even George Seurat's *A Sunday Afternoon on the Island of La Grande Jatte*, to register the potency of that pictorial, indeed societal, fantasy. And yet, even as Smithson's sketch repeated something of that structuring desire for release, for respite, for refuge, it also put forth a different sort of fantasy, another set of possibilities. An island with neither inhabitant nor visitor, a floating park as inviolable preserve, a sculptural evocation of the primordial landscape that once was Manhattan as it is at once figured and forgotten in Central Park; in his plan for *Floating Island*, Smithson proposed a sight and site that necessarily remains, in its watery distance and its conceptual displacement, a non-site, a non-place, an instantiation of utopian desire, if not utopia.

At the time of its conception, coming as it did at the tail end of a decade that saw the reinvention of and reinvestment in utopian ideals, conditions of historical possibility at once authorized and foreclosed Smithson's utopian vision. In its belated realization in 2005, *Floating Island* launched a utopian vision forged in the late 1960s into a wholly altered historical situation. Tethered to a tugboat as it

trolled the waters of Lower Manhattan, *Floating Island* was also anchored by its new present, one defined by the events of September 11 and all that emerged in their aftermath. A time capsule of sorts, *Floating Island* emerged in a cultural landscape structured neither by the urban planning imperatives of reclamation and renewal nor by visions of utopian possibility—even if rebuilding was a governing concern and the idea of the island, as a kind of fortress, resurfaced as a paradigm of insular safety.

In the days, months and years that followed from that September of 2001, New York became a site of memorials, personal and collective, temporary and permanent, impromptu and commissioned. These works of commemoration took the form of everything from the initially pragmatic posted photographs of the missing to the ethereal and elegiac projected beams of light that, for several September 11s to follow, restored to the skyline, if only as spectral trace, the architectural presence of the twin towers. Michael Arad's memorial proposal for pools tracing the footprints of the towers, Daniel Libeskind's architectural renderings of the Freedom Tower, Paul Chan's looping video projection of falling bodies and objects as pure shadow, Jonathan Borofsky's sculptural evocation of figures climbing into the sky, the energies of artists and architects produced an almost immediate cultural landscape of encounter, if not remembrance.

In the midst of all of this commemorative activity, the writer Jonathan Safran Foer

published his second novel, *Extremely Loud and Incredibly Close*, 2005, just a few months before Smithson's *Floating Island* appeared in the waters off Lower Manhattan. Narrated by Oskar Schell—a precocious, imaginative, grief-stricken nine year old New Yorker, whose father was killed in the World Trade Center—the story is interspersed with images and by the voices of two others: Oskar's absent grandfather, writing letters to Oskar's father that are never received, and Oskar's doting grandmother, writing words to Oskar that he never sees. Taken together these comprise a book within a book, revealed to be Oskar's scrapbook only at the novel's end. The novel also holds within its complex and capacious structure the short story "The Sixth Borough": a magic realist tale of the eponymously titled island conjured into fictive reality by Oskar's father, in a bedtime story, the night before his death—the night before the day that will be known as September 11.

First published as a stand-alone short story in *The New Yorker* in 2004 and embedded deep in the armature of the novel, "The Sixth Borough" imagines an urban geography and sociality incrementally reconfigured by geological time. In his story, Foer imagines a beloved borough turned wayward island, ultimately largely abandoned as it is drawn south toward the undifferentiated landmass of Antarctica and preserved, at least in part, in the rescue operation that gives to the isle of Manhattan that island of nature, that monument to the idea of landscape that is

Central Park. In "The Sixth Borough", bridges and social ties give way to the pull of tectonic forces. And when attempts to 'save' the borough fail, the residents of the city demand that it be remembered. In turn, a referendum is held and Central Park is expressly established to salvage and preserve the cherished green space of the receding borough, the transfer engineered to create a public park that is a site of memory—if only rather vaguely and somewhat magically—of another place and time, a better time and place.

Smithson—whose 1966 *Proposal for a Monument at Antarctica* was conceived even before his 'island' projects—imagines, in his New York *Floating Island*, a park as island, an island as park, preserved as a kind of monument and memorial to all that an urban park might be, to that non-place that, as I have suggested, we might want to call utopian, if not utopia. That something of More's eponymous island and all that it inspired should find itself echoed, in the aftermath of September 11, not only in Smithson's belatedly realized non-site, and in Foer's "Sixth Borough", but also in Krzysztof Wodiczko's City of Refuge—an island of critical memory, engagement and study, at once agonistic and emancipatory, infused with the ethical imperatives of Emmanuel Levinas and adrift in the waters just off Manhattan—suggests that perhaps utopian desire has come together with something that we might call utopian form. It suggests that sites of artistic and literary imagination have joined forces with something that we once called memorials or

monuments to give us a different kind of site, a different kind of non-site, a counter-memorial that might indeed be utopian, for it may hold within it the possibility to engage the past, to engage the present, and to remember, with all of the complexity and contradiction, the culpability and the capacity for change, that commemoration, in its ideal form, requires.

That said, Foster does not follow this point with a discussion of Smithson's non-sites, pursuing instead the significance of Dean's anti-messianic, archival interest in "failed futuristic visions". For another discussion of the 'failure' of utopian visions, see TJ Demos, "The Cruel Dialectic: On the Work of Nils Norman", Grey Room 13, Fall 2003, pp. 32–53.

1. For a discussion of Smithson's work, see, among other sources, Ann Reynolds, Robert Smithson: Learning from New Jersey and Elsewhere, Cambridge, Mass.: MIT Press, 2003, Jennifer L Roberts, Mirror-Travels: Robert Smithson and History, New Haven and London: Yale University Press, 2004, Eugenie Tsai et al, Robert Smithson, Los Angeles: Museum of Contemporary Art, Los Angeles and University of California Press, 2004.

2. For a discussion of the literatures and philosophies, past and present, of utopia, see Fredric Jameson, Archaeologies of the Future: The Desire Called Utopia and Other Science Fictions, London and New York: Verso, 2005. See also Edward Rothstein et al, Visions of Utopia, New York: Oxford University Press, 2003.

3. Hal Foster, in his "An Archival Impulse", October 110, Fall 2004, pp. 3–22, calls our attention to Tacita Dean's reading of Smithson, both in her work engaging his Partially Buried Woodshed and Spiral Jetty and also in her reflections on her own 'sound mirrors', set and shot in once futuristic, now obsolete English military architecture, and points out that her invocation of 'no place' demonstrates an awareness of the literal meaning of utopia.

4. Robert Smithson, "Frederick Law Olmsted and the Dialectical Landscape", Artforum, vol. 11, no. 6, February 1973, pp. 62–68.

DANIEL BERTRAND MONK

THE POLITICS OF PSEUDO-MORPHOSIS

And with Stratagems/Devices Make War

(Proverbs 20:18)

Krzysztof Wodiczko's *oeuvre* has always been bound up with two preoccupations. In the *Homeless Vehicle* projects, totemic projections, and prosthetic communication devices—all preceding his current proposal for a floating cenotaph to the political memory-work still to be done for *all* the victims of 9/11—one is repeatedly presented with the problem of a humanity inadequate to its own concept and with the corresponding predicament of an art that would seek to make this fact not only visible, but somehow *manifest*. In giving a shape to what will otherwise fail to appear, Wodiczko's art keeps faith with the ambitions of a humanity that would be consistent with its own idea; but in demanding that form somehow participate in summoning another political reality into being (by 'instantiating' the unacknowledged barbarity of the current one), Wodiczko's *oeuvre* breaks faith with its own medium—art—which differs from philosophy because it can only tell the truth in the form of illusion.

Wodiczko's *Homeless Vehicle*, for example, made what was already the case into something 'actual'—in the sense of turning those living informally and in ad-hoc fashion out of shopping carts into the official homeless. In the process, he gave a dispossession otherwise subjected to metropolitan indifference a discernible form. If it was an outrageous construct, that is because in its very appearance the vehicle refused

society's demand for homelessness consistent with the view that a resort to such devices was outrageous to begin with. (The device, its critics argued, signaled a capitulation to an order that would consider homelessness a condition to be ameliorated rather than done away with *en toto*.) At the same time, the vehicles themselves turned their operators into instruments for the indictment of a liberal anguish, and seemed to justify the assumption that the act of making the truth of our real indifference to homelessness manifest would in itself be politically transformative.

Similarly, when Wodiczko later projected a remarkable series of images onto monuments around the globe, he suborned architectural Classicism's privileged association with universal reason by pointing to the ends of that same reason: the swastika in one instance, and the atom bomb in another. Brilliantly negating the world's course as either necessary or rational in this fashion, Wodiczko nevertheless impressed the projections into the service of an absurd traumatology, in some sense expecting photons to do the job of restoring enlightenment when all the light of his slides could do was to spotlight its absence, or more properly, point to 'a weak and distant reason' that Wodiczko himself helps to render even more remote by asking the projections to do more.

If one interprets this *oeuvre* in light of its own immanent progression (rather than as a consequence of Wodiczko's own stated intentions), one can only surmise that it is the artworks' own refusal to serve the function demanded of them that in turn caused the artist to 'animate' the projections, quite literally. Wodiczko's next series of projections turned to audio and video testimonials that bombarded the anguished declarations of the mothers of murdered sons, for example, onto existing memorials like the Bunker Hill Column in Boston. This kind of 'extorted reconciliation' of particular and universal is best illustrated by a projection in Japan, in which the iconic Hiroshima Dome wrings its 'hands' and sometimes pours an offering into the Ota River as it simultaneously narrates the testimony of Hiroshima's survivors and their descendants. If these projections sanctioned catharsis in *prosopopoeia* because they made a mute architecture speak for silenced bodies, they simultaneously impressed the suffering of others into the service of a vulgar logic: here, trauma repeatedly becomes the means to another end....

Those were the good old days of Wodiczko's production, just as they were lovely times for bourgeois anguish. 'Lovely', because in the responses that his batteries of light occasioned in places like Jerusalem, London, and Brooklyn during the waning years of the twentieth century, one was offered proof that such anguish still existed, or was at least experienced in a manner similar to an amputee's 'phantom limb' syndrome. (The subsequent extinction of that anguish can be confirmed anecdotally: a number of years ago, a group of undergraduates were confronted

with the paradoxes of the homeless vehicle project and asked to debate whether it was better to acknowledge and ameliorate life on the street or to confront efforts like the vehicle project as capitulations to inhumanity; the students quickly reached consensus, arguing that no public resources should be squandered on *either* the vehicle or homeless shelters, and that homelessness was effectively 'not their problem'.) Now that we live in a moment in time when the extortion of surplus value from the wretched of the earth can win you the Nobel Peace Prize—on the utilitarian assumption that micro credit is noble because it thwarts dependency—no one feigns outrage at homelessness any more, just as no one gives a damn if you project the image of an ICBM or a video of a grieving mother onto a war memorial. They're too busy watching elected officials justifying torture on television.

The impossibility of Wodiczko's most recent proposal, or in other words, the suspicion that his project is little more than a floating *cenotaph* to a humanity that was once capable of reflexive speculation on ethical praxis, originates precisely here: in the suspicion that the kind of political organism that might once have known what to see in or do with his sphere—and which for that reason would not have needed it—no longer exists. Having been replaced by a kind of creature that treats the events that inaugurated the need for the 9/11 cenotaph as justifications for the kinds of moral and political exceptionalism that followed in 9/11's wake, the occupants of the 'more-than-less-than' institute-memorial proposed in these pages are absent, or merely ghosts.... Perhaps this is why the cenotaph's depicted cross-section is entirely devoid of human beings.

The living, on the other hand, are expected to perform penance in a vulgar caricature of agonistic memory-work that Wodiczko credits with the ability to usher in a reality different than the one we make. Wodiczko's 'more-than-this and less-than-that' 9/11 memorial demands that the public accept responsibility for the violence the state has perpetrated in its name, in return for pilpulistic assurances that its complicity-by-inattention with the killing of innocents is really a lot more like involuntary manslaughter than murder. This plea bargain in the form of a monument explains the project's program as a City of Refuge modeled on the biblical *arei miklat*. But it also invites speculation on Wodiczko's curious turn to what was once called an *architecture parlante*. After all, when his previous projections turned monuments into little more than scaffolds for the delivery of the historical message latent in their own failure to deliver a message, the images necessarily drew their strength from the *weakness* of an allegorical architecture.

One can only/may surmise that this is because the nature of spectacle has itself been transformed by the events the cenotaph attempts to "work through" on behalf of a liberal consciousness. When you smash commercial airliners into the world's tallest buildings, and in the process show people for

the first time the shocking correspondence in scale between towers and airplanes, the nature of spectacular montage (the device upon which Wodiczko's aesthetic interventions have always depended) is itself also transformed... And so *are its effects*. One of the disgusting and unacknowledged secrets of 9/11 is that all the deaths associated with that horror were unconsciously discounted as worthwhile by a humanity hungering for unregimented experience, and expressing that legitimate hunger illegitimately in clichéd expressions about the event's sublime incommensurability with 'anything ever seen before'. In this fashion, political exceptionalism was confirmed in aesthetic terms, and a continuous history of horror since Auschwitz was demoted to the 'been there, done that' ranks of 'extreme' political experiences. And so, having been robbed by historical events of the devices that would allow art to present the truth of conventional memorials immanently—in the untruth revealed by the sudden montage of image on building—Wodiczko is forced to seek refuge in a City of Refuge.

In the end, all that is left of Wodiczko's earnest demand for another politics is its insistence, which asserts itself all the more stridently in a prolonged rebuke of those who will not recognize in his floating City of Refuge a transformative superimposition of traumatology and radical democratic practice. (That new, strange montage of intellectual horizons is not supposed to be confused with a hypostasis of occupational therapy

to the level of praxis, even though that is exactly what it is.) What will not present itself to view out of the insufficiency of a world of appearances must now be forced to appear at the expense of the enlightenment that would make such truths meaningful. And, as if in tacit acknowledgement of this predicament, Wodiczko's political talking cure is quite literally expected to take place in a bubble. In that space, political claims nominally give way to healing and demands for justice are traded in for reconciliation, in a ruse of reason that suggests nothing is lost in that bargain. If discerning viewers may find all of this to be horrific, that is probably because they cling to the quaint notion that art is politically transformative only when it points toward an autonomy that is nowhere else on offer. They refuse to acknowledge as necessary the exchange between truth and political accommodation that is proposed in a 'more-than-less-than' monument, or to regard that quid pro quo as the triumph of the world spirit. They demand refuge on dry ground.

MEMORIAL
PLANS

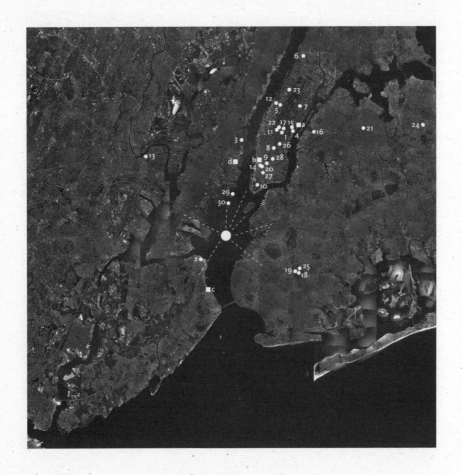

● PROPOSED SITE FOR THE CITY OF REFUGE A 9/11 MEMORIAL

● POTENTIAL SYMBOLIC SITES, INSTITUTIONS AND ORGANIZATIONS TO BE AFFILIATED WITH THE CITY OF REFUGE: A 9/11 MEMORIAL

1 National 9/11 Memorial (Under Construction)

2 Staten Island 9/11 Memorial

3 The Hoboken 9/11 Memorial
 (Under Construction)

4 United Nations Headquarters
 UNESCO Office (within UN)
 UNICEF Headquarters

5 Open Society Institute and
 Soros Foundations Network

6 Columbia University

7 Hunter College

8 The New School for Social Research

9 New York University

10 American-Arab Anti-Discrimination Committee

11 Amnesty International USA

12 CUNY Dispute Resolution Consortium

13 Immigrant Rights Program
 American Friends Service Comittee

14 International Trauma Studies Program

15 NY Tolerance Center
 Simon Wiesenthal Center

16 Outward Bound Center for Peacebuilding

17 Program on States and Security

18 Coney Island Avenue Project
 (Assistance for South Asian and Muslim
 communities against the anti-immigrant
 backlash in the wake of 9/11.)

19 Council of Peoples Organization
 (Fulfilling the "dreams" of Asian Americans)

20 Doctors of the World—USA

21 DRUM Desis Rising Up and Moving
 (For South-Asian low wage immigrant workers,
 families fighting deportations.)

22 Families for Freedom
 (Multi-ethnic defense network
 against deportations)

23 Jewish Community Center in Manhattan

24 Muslim Center of New York

25 Muslim Community Center

26 Peaceful Tomorrows

27 Safe Horizon
 (Moving victims of violence from crisis
 to confidence)

28 War Resisters League

29 The Ellis Island Immigration Museum

30 The Statue of Liberty

■ HOMELAND SECURITY

a New York State Homeland Security Office

b Homeland Security
 The Environmental Measurements Laboratory

c Underwater Security Associates
 Homeland Security

d Department of Homeland Security OIG

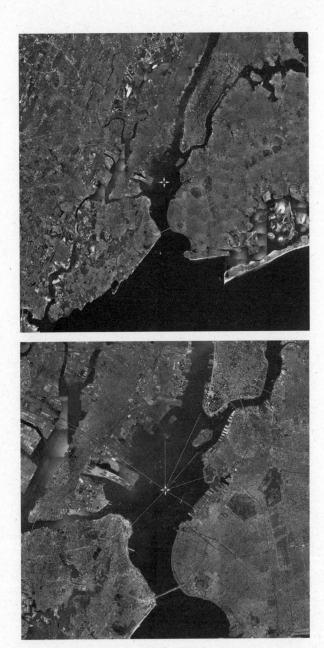

The main body of the memorial to September 11 will assume the form of a sphere, a floating, slowly rotating structure located in a stationary position at the center of New York City harbor. Stationed at a distance from the sphere will be the four floating spherical satellites. Especially designed ferries will provide a means of transit between the memorial's sphere and New York City. The ferries will be first arriving at the satellites; after being docked to them, they will be 'escorted' to the four gates of the sphere.

The ferries will be arriving at the sphere from all the sites relevant to the memorial's mission: urban centers, organizations, institutions, symbolic areas, sites located in various points of Manhattan, Harlem, the Bronx, Brooklyn, Queens, Long Island City, New Jersey, Staten Island, Governors Island, Statue of Liberty, and Ellis Island. (See the map of the potential symbolic sites, institutions and organizations to be affiliated with the memorial to September 11, page 82.)

The sphere will contain a forum—a semi-spherical auditorium for debates and presentations. The forum will be designated to accommodate and inspire free expression, disagreements, antagonisms and the presentation of continuing, unfolding or potential 'malignant', destructive conflicts in the world.

The forum will be equipped with mechanically movable platforms capable of coming close or shifting away from each other while maintaining safe distance between the quarrying speakers, during their dynamic and passionate presentations and agonistic debates.

The Heads and Members of Delegations taking part in the sessions in the forum will be able to present their points of view both directly as well as in technologically mediated ways, and will thus be able to increase, reduce or modulate their ways and forms of expression.

The platforms will also be equipped with small internal auditoria to allow the delegations to conduct roundtable inner debates before, after and during the intermissions of the sessions in the forum.

Above the forum there will be an Urban Communication Center equipped for coordination and communication with and among the New York City urban centers, organizations, institutions, and other sites and points related to the memorial activities (see again the map, page 82).

Around the forum the large spaces and facilities will be designed to assist in media events, performances, conferences, colloquia, symposia, and commemorative gatherings, as well as in special 'Conflict Transformation' ritualistic events and other cultural activities related to peacemaking.

Below the forum, at the very center of the sphere there will be a 'situation room' that will be displaying unfolding and potential conflicts and post-conflict zones and developments. The central part of the 'situation room' will be a globe equipped with a dynamic audiovisual display capability. The globe will be accessible to visitors from both the outside and the inside to allow for engaged learning of the conflict situations, and troubled world zones from two perspectives: one, as if seen from the Earth's 'orbit' (the spiral observing deck) and another (when inside the globe), as if 'seen through' from the very center of our planet.

Below and around the 'situation room' there will be a Conflict Transformation Center, and a Peace Building Institute equipped with facilities for research and project development in a local, regional and global scale. Under the water, sections of the sphere will contain a Cultural and Clinical Trauma Healing Institute, a Cultural Action and Emergency Response Center, a Justice and Reconciliation Network, a Legal Expertise and Aid Network, a World Conflicts and Peace Making Database, and other resources and facilities.

The journeys to the satellites by the especially designed ferries, the process of docking the ferries to the satellites and escorting them to the sphere, the special interactive media programs and events accompanying this process will have an elaborate ritualistic character. They will function as 'liminal' events, a kind of 'rite of passage' to prepare New Yorkers for conscious engagement in the mission and work of the memorial.

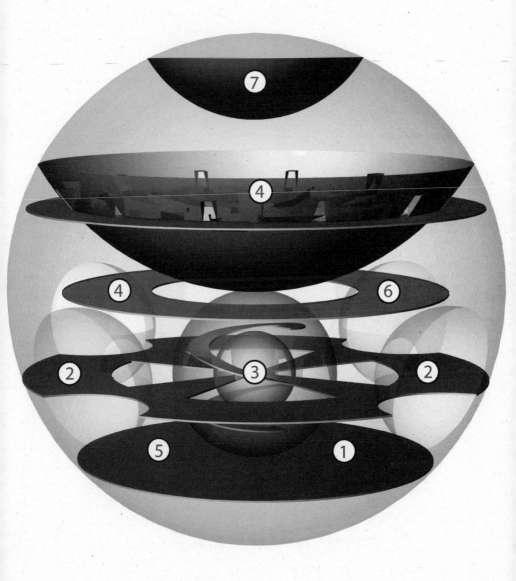

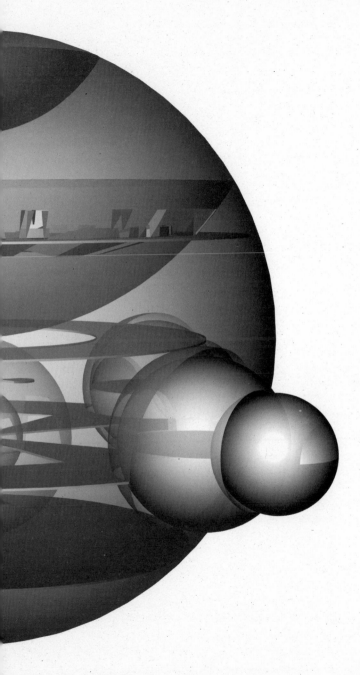

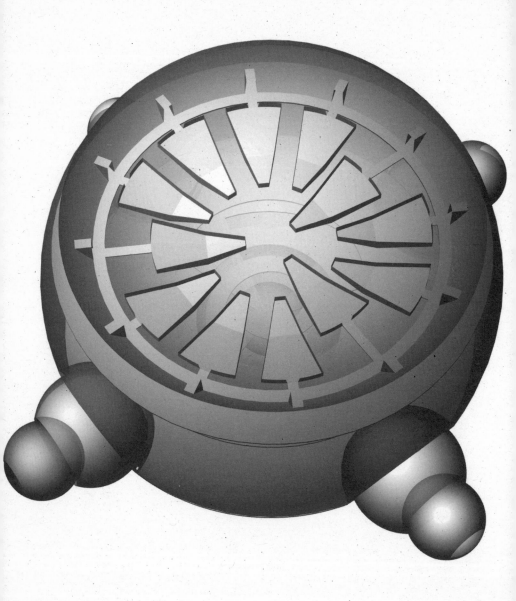

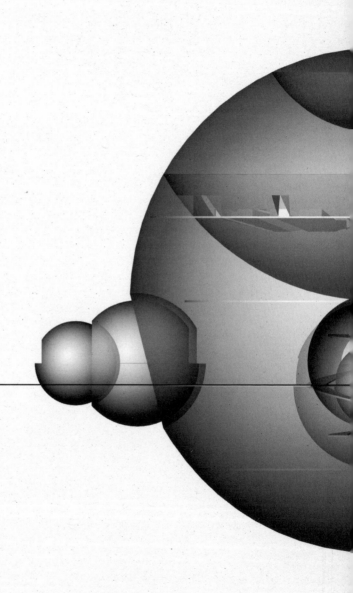

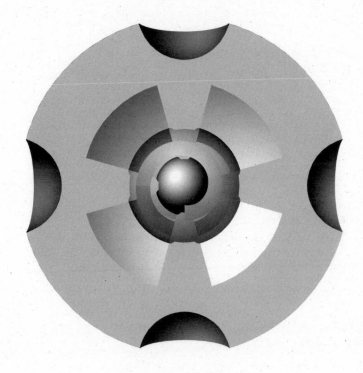

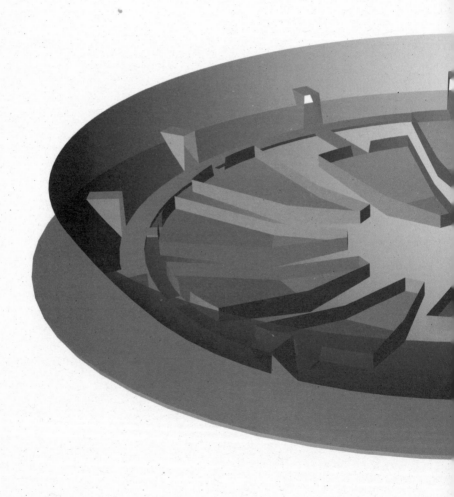

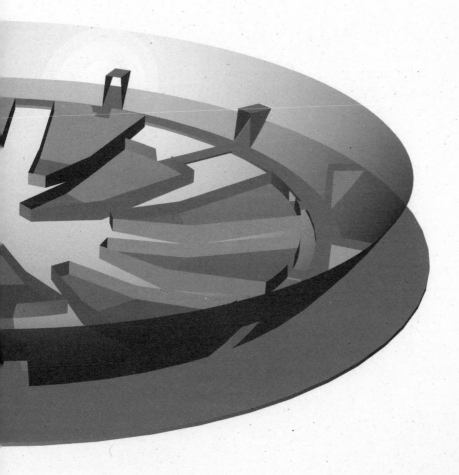

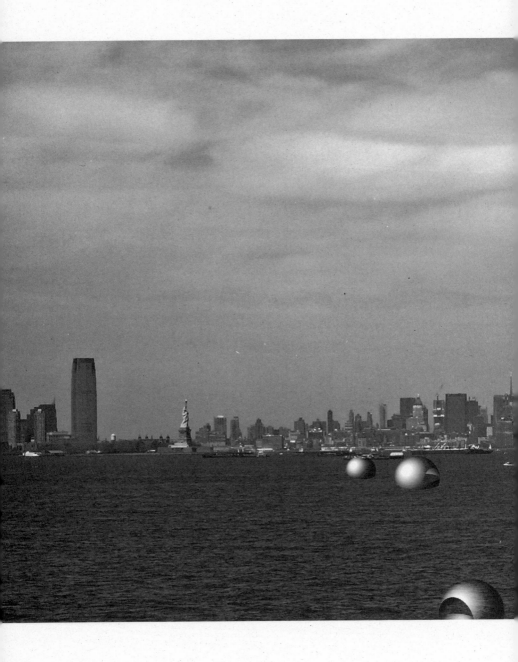

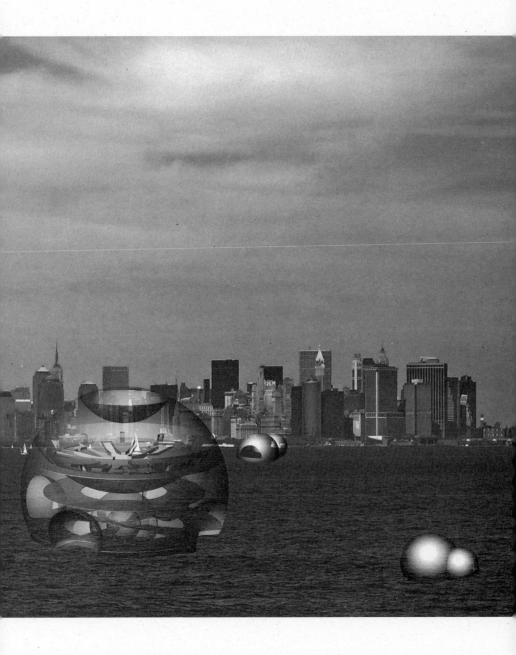

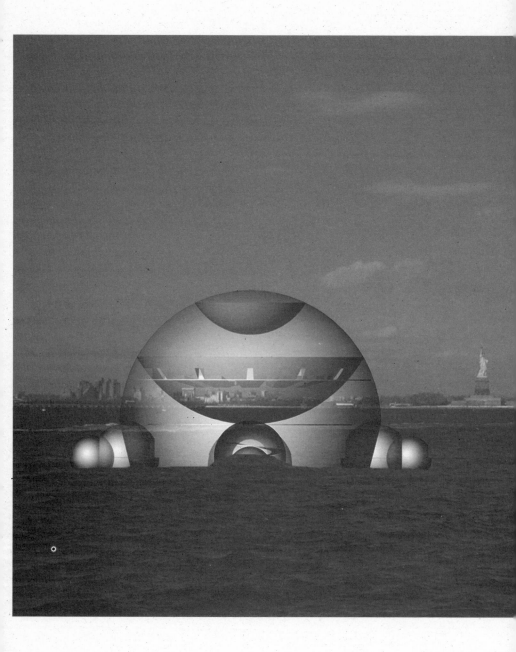

END
MATTER

KRZYSZTOF WODICZKO

is Professor of Visual Arts, head of the Interrogative Design Group and director of the Center for Advanced Visual Studies at MIT. He is internationally renowned for his large-scale slide and video public projections on architectural facades and monuments, more than 80 of which have been realized worldwide, each tailored to match political commentary with the site of the projection. Since the early 1990s, Wodiczko has also been designing and publicly implementing a series of performative devices called Instrumentations, that began with the *Alien Staff* (1992), a kind of walking stick to be carried by an immigrant during his or her peregrinations. Built into the stick was a tiny video monitor and speaker for dissemination of immigrant stories as well as a clear container housing valuable papers such as work visas, green card, etc. Among his most recent Instrumentation projects is the War Veteran Projection Vehicle, a mobile communication equipment allowing returning soldiers from Iraq and Afghanistan to project their voices and messages onto the facades of public buildings. In association with the architect Julian Bonder, Wodiczko has designed a Memorial to the Abolition of Slavery planned to be opened in Nantes, France in 2011.

Since 1985, Wodiczko has held retrospective exhibitions shown at the Walker Art Center, Minneapolis; Museum Stuki, Lodz; Fundació Antoni Tàpies, Barcelona; Center for Contemporary Art, Warsaw; Stichting De Appel, Amsterdam; Zacheta National Gallery of Art, Warsaw; and the Museum of Contemporary Art San Diego—La Jolla. His next major retrospective exhibition is planned to open at the Museo Nacional Centro de Arte Reina Sofia, Madrid in 2011. Wodiczko's work was presented in international exhibitions including Les Magiciens de la Terre, Paris; Biennale de Paris; Documenta, Kassel; Venice Biennale; Biennale de Lyon; Whitney Biennial; Yokohama Triennale and many others. He is the recipient of the Hiroshima Art Prize (1998), the Kepes Art Prize (2004) and the Skowhegan medal for Sculpture (2008), among others honors. He represented Poland in the 2009 Venice Biennale.

MARK JARZOMBEK

is Professor of History and Theory of Architecture and Associate Dean of the School of Architecture at MIT. He has written on a wide range of topics dealing with cities, trauma and modernity. *Urban Heterology: Dresden and the Dialectics of Post-Traumatic History*, Vol. 2 in the *Studies in Theoretical and Applied Aesthetics*, 2001, analyzed the politics of the urban imaginary in the destruction and rebuilding of Dresden.

DANIEL BERTRAND MONK

holds the George R. and Myra T. Cooley Chair in Peace and Conflict Studies at Colgate University, where he is a professor of Geography and director of the Peace and Conflict Studies Program [P-CON]. He is the author of *An Aesthetic Occupation*, 2002 as well as a number of other studies on the Israel-Palestine conflict. Together with Mike Davis he has edited *Evil Paradises: The Dreamworlds of Neoliberalism*, 2007. He has been awarded MacArthur, IPS, and Woodrow Wilson Fellowships for his research on the history of strategic interaction in the Arab-Israeli conflict and its spacial practices.

LISA SALTZMAN

is Professor of History of Art at Bryn Mawr College. She is the author of *Anselm Kiefer and Art after Auschwitz*, 1999, and *Making Memory Matter: Strategies of Remembrance in Contemporary Art*, 2006, and co-editor of *Trauma and Visuality in Modernity*, 2006.

KIRK SAVAGE

is Associate Professor and Department Chair of the History of Art and Architecture at the University of Pittsburgh. He is the author of *Monument Wars: Washington, D.C., the National Mall, and the Transformation of the Memorial Landscape*, 2009 and *Standing Soldiers, Kneeling Slaves: Race, War, and Monument in Nineteenth-Century America*, 1997.

ANDREW M SHANKEN

is Assistant Professor of Architecture at Berkeley. He has written extensively on memorial culture, including "Planning Memory: The Rise of Living Memorials in the United States during World War II", *Art Bulletin*, March 2002. In 2009, he published *194X: Architecture, Planning, and Consumer Culture on the American Home Front*. His forthcoming publications include "Memory and Its Discontents: On the Fringes of the Memory Industry", *Spatial Recall*, Marc Treib ed., 2009, and "Towards a Cultural Geography of Memorials" in *Festschrift to Eric Fernie*, Christine Stevenson ed., 2010.

MECHTILD WIDRICH

received her Ph.D. from MIT in 2009. Her dissertation is entitled *Performative Monuments. Public Art and Commemoration in Post-war Europe*. She recently published in *Photography between Poetics and Politics*, 2008; an article on performance art is forthcoming in *Perform, Repeat, Record: A Critical Anthology of Live Art in History*, 2009. She has held visiting lectureships at the Department of Art History of the University of Vienna, and the Art University Linz.

ACKNOWLEDGEMENTS

The editors would like to thank Jegan Vincent de Paul for assisting with the visualization, Nikolaos Kotsopoulos and Johanna Bonnevier at Black Dog Publishing for the professional and passionate work on this project, and Anneka Lenssen and Andrei Pop for critically reading the texts.

COLOPHON

© 2009 Black Dog Publishing Limited, London, UK,
and the authors. All rights reserved.

Edited by Mechtild Widrich and Mark Jarzombek.
Assisted by Nikolaos Kotsopoulos at Black Dog Publishing.
Designed by Johanna Bonnevier at Black Dog Publishing.

Black Dog Publishing Limited
10A Acton Street
London WC1X 9NG
info@blackdogonline.com
www.blackdogonline.com

All opinions expressed within this publication are those
of the authors and not necessarily of the publisher.

British Library Cataloguing-in-Publication Data. A CIP
record for this book is available from the British Library.

ISBN 978 1 906155 80 3

All rights reserved. No part of this publication may be
reproduced, stored in a retrieval system, or transmitted,
in any form or by any means, electronic, mechanical,
photocopying, recording, or otherwise, without prior
permission of Black Dog Publishing Limited.

Black Dog Publishing Limited, London, UK, is an
environmentally responsible company. *City of Refuge:
A 9/11 Memorial* is printed on Dalum 170gsm
Recycled paper

RICHMOND HILL
PUBLIC LIBRARY

JAN 6 2010

RICHMOND GREEN
905-780-0711